IMAGES
of America

FRANKLIN

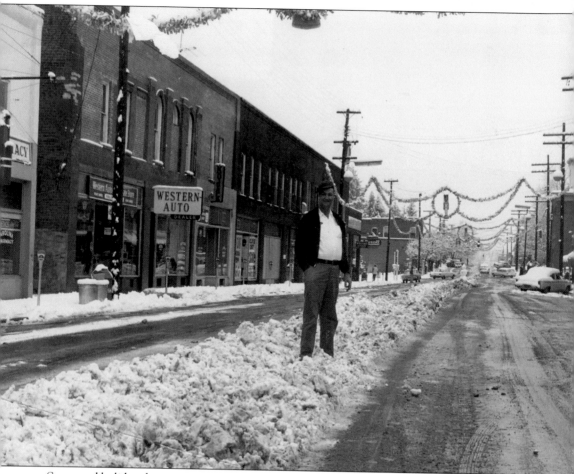

Snow and holiday decorations create a Christmas scene in this photograph, taken on Franklin's Main Street in the late 1960s. The old courthouse, demolished in 1972, can be seen at center right. Since this image was captured, the stores have changed, utility lines have been buried, the parking meters have been removed, and traffic on Main has been made one-way, but those familiar with the town will recognize the street instantly. (Macon County Historical Society.)

ON THE COVER: The Atlantic and Pacific Tea Company, better known as the A&P, opened a store in Franklin in 1930, near the courthouse in the building later known as the Mini Mall. It was Franklin's first chain store, which set off a furor. Local merchants worried that it would destroy their business. However, they soon began to adapt, and one early critic later said, "I used to be an order taker. The A&P made me become a merchant." In this photograph, John McCollum is the man on the right. (Macon County Historical Society.)

IMAGES
of America

FRANKLIN

Barbara McRae and Cherry Jackson

ARCADIA
PUBLISHING

Published by Arcadia Publishing
Charleston, South Carolina

Printed in the United States of America

Library of Congress Control Number: 2013933049

For all general information, please contact Arcadia Publishing:
Telephone 843-853-2070
Fax 843-853-0044
E-mail sales@arcadiapublishing.com
For customer service and orders:
Toll-Free 1-888-313-2665

Visit us on the Internet at www.arcadiapublishing.com

To our mothers, Mary Hoch Sears and Cherry Sue Orr Jackson

CONTENTS

ACKNOWLEDGMENTS

The authors greatly appreciate the help and moral support provided by Robert Shook, Bob Poindexter, and other members of the Macon County Historical Society. We are grateful to the society for graciously sharing photographs from the historical museum's collections. These photographs make up the majority of the images in this book. We also wish to acknowledge the many individuals and families who shared their photographs with the historical society; their generosity made this book possible. Likewise, we recognize those whose efforts through the years have made it possible to amass a remarkable visual history of Franklin, especially the photographers, many unknown, who recorded that history on film, and the *Franklin Press*, which preserved it in printed form.

Many friends helped us check facts and locate photographs, and we thank them. We especially thank Gordon Mercer for featuring us on his radio program *Citizens Making a Difference*. We cannot forget our editor, Katie McAlpin, who has provided constant encouragement and, when necessary, wise advice.

Unless otherwise noted, all images are courtesy of the Macon County Historical Society.

INTRODUCTION

Franklin sits on a beautiful hill above the Little Tennessee River, with the great chain of the Nantahala Mountains to the west and the Cowee range to the east. The site was chosen in 1820 by the Love Survey Party, whose task it was to map the huge, sprawling tract recently ceded by the Cherokee Indians. The surveyors did not know that the site they liked so much had been occupied by Native Americans for more than 2,000 years. They were well aware that five well-traveled roads (rather, trails) met here, making the location convenient for commerce. They took pains to set the town on a hill above the river to make it safe from floods and take advantage of the beautiful setting the spot provided.

Franklin was to be the market center of the new territory and the seat of the county that would eventually be established. It was laid out according to a simple, time-tested plan, with a main street, a cross street, and a public square in the center. Twenty narrow, one-acre lots were laid out along Main Street. This plan, though a straightforward one, would guide the growth of the town down to the present day.

Most of the original settlers came to the new territory from counties to the east, especially from Haywood (the mother county) and Buncombe. They were primarily of Scots-Irish, German and English descent, offspring of the vast wave of pioneers who, for the previous century, had followed the Great Wagon Road from Pennsylvania southward. Wealthier families brought their slaves with them to help with the task of developing the new lands. A small but important population of free African Americans came as well.

As the county grew, Franklin served (and still serves) as the center of its commerce, education, entertainment, medical services, and government. Tourism began to develop before the Civil War. Franklin offered cool summers, pure water, and little disease—great incentives for those who could afford to leave their homes in the deeper South for the season. Hunting and fishing also drew visitors who could stay in one of the local inns or board with a family and hire a guide.

In 1855, Franklin became incorporated. At that stage, it was still very much a frontier town. The set of ordinances adopted in 1859 forbade (with limited success) running a horse race through the streets "for show, pleasure or reward." Horses were not to be ridden on the sidewalks, and "unnecessarily" firing a gun brought a fine of $1.

The slow trajectory of Franklin's growth was interrupted by the Civil War. Though no large battles were fought in or near the town, the town earned the distinction of hosting what is thought to be the final surrender of Confederate forces in the East on May 14, 1865.

The war took an enormous toll and changed people's lives for both good and ill. But, by the 1870s, prosperity returned, and merchants began to make significant investments in the town. In 1874, a travel piece in *Scribner's Monthly* enthused, "The chief town of Macon County was fair to look upon, seated amidst well-cultivated fields, and in the immediate vicinity of a grand grazing country."

The town began to attract new residents, businessmen, and investors. In 1886, T.J. Christy came from Athens, Georgia, and began publishing a weekly newspaper, the *Franklin Press*, which is now the oldest business in the county.

Though a few treasured photographs survive from early years, the late 19th century begins to provide a more complex visual record of Franklin and its people. The images offer glimpses into the establishments operated by the early merchants and those who followed them.

In the early 1900s, the county got its first bank, the Bank of Franklin. Telephone service, electric power, and a small library added to the improvements available to town residents. The Tallulah Falls Railroad reached Franklin in 1907. Despite this being the end of the line, the train had a significant impact. Not only did it bring tourists to town, but it also provided freight options that made it possible to exploit the county's rich natural resources. The logging and mineral industries created jobs and brought many new faces to town. By 1920, the population had grown to 773.

For Franklin folks, the 1920s were something of a golden era. The town prospered and grew, thanks in part to the automobile, which made it much easier for folks in the country to make regular trips to the county seat. This was an era of big dreams. Local developers built a municipal power plant on the Little Tennessee River and envisioned a great resort on the reservoir. These rosy dreams were never fulfilled, thanks to the financial crash of 1929.

The Great Depression brought hard times to Franklin but also new opportunities. The Bank of Franklin weathered the storm. Nantahala Power and Light Company moved its headquarters to Franklin from Bryson City. The Nantahala National Forest, also headquartered here, got a boost from new federal programs, such as the Civilian Conservation Corps (CCC). Recreational areas developed by federal workers drew tourists who longed to explore the mountains and still remain popular destinations for visitors.

During the Depression years, many locals moved away in search of opportunities, and the exodus continued during World War II. Between 1940 and 1943, one out of every eight people left the county, either for military service or work. By war's end, 1,646 men and women, of a total population of 15,880, had served in the military. The war and its aftermath meant great changes for little Franklin. Returning soldiers brought new ideas home with them, including an interest in flight. The first airport and flying service was established in 1945 in the bottomland along the Little Tennessee River. Grant Zickgraf, co-owner of the airport, also developed his lumber business into a major industry.

Despite the population drain of the war and postwar years, the people of Franklin and surrounding areas discovered new reasons for civic pride and made an effort to make their town an appealing and fun place to be. In 1955, folks went all out to celebrate Franklin's centennial, with festivities that attracted Gov. Luther Hodges and other dignitaries.

In the 1960s, the region benefited from several large trends taking place in the country. People began moving back to rural America. Growth in the Sunbelt brought new industries, as well as new people, to the area. Also, people were living longer, and an affluent group of seniors now had the means to retire wherever they wished. For many, that meant finding a small town like Franklin with an excellent quality of life. Their contributions have helped the town move forward, while holding onto the traditional, down-home values the photographs in this volume depict.

One

OLDEN DAYS

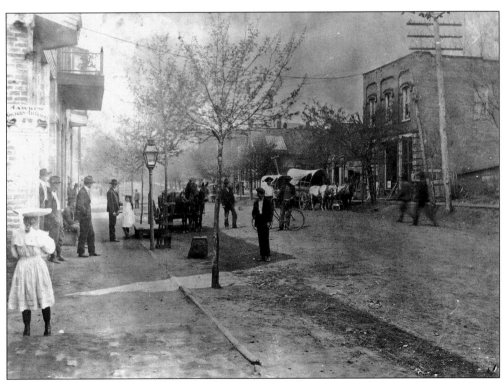

In 1904, the maples that gave old Franklin much of its charm were still young. The streets were dirt; the sidewalks, wooden. Most folks got around on their own two legs or used horses, mules, or steers for transportation, and covered wagons were still a practical necessity. Trotter's Store, seen upper right, held Franklin's first photography studio and was also the first location in Franklin to have a telephone.

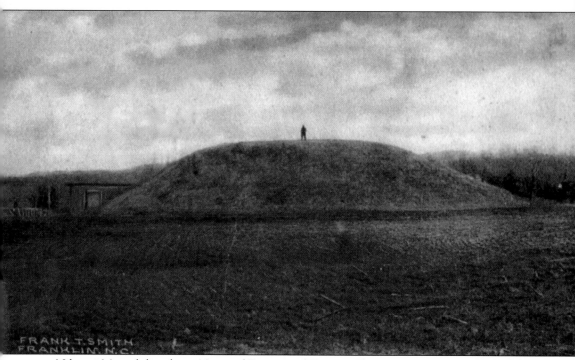

Nikwasi Mound, listed as a National Register of Historic Places property, was protected during the 1940s after a drive by the newly formed Macon County Historical Society succeeded in raising enough money to purchase the one-acre site it occupies. The best-preserved Indian mound in Western North Carolina, it formerly occupied the center of Nikwasi, the sacred town of the Middle Cherokees. (Barbara McRae.)

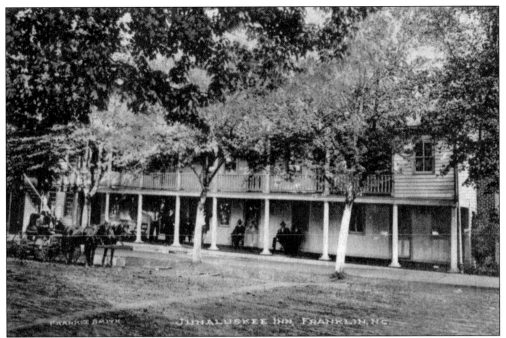

Irad Hightower bought Lot 10 of the original town plat in 1820 and built what was considered the county's first "proper" house, as it was made of hewn logs rather than round logs. Gideon F. Morris acquired the property in 1830 for $1,600. He sold it to J.R. Allman; the mortgage describes the property as having a dwelling, "publick house," storehouse, and outbuildings. It was later operated as the Junaluska Inn.

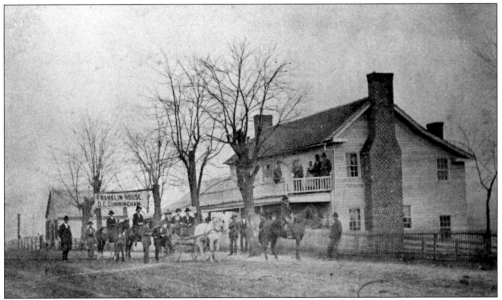

Dewitt C. "Dee" Cunningham operated a hotel called Franklin House in the late 19th century; he also ran a livery stable next door. The west portion of Franklin House was a log structure that had housed the county court before construction of the first courthouse in 1829. The building was damaged in the great fire of 1894.

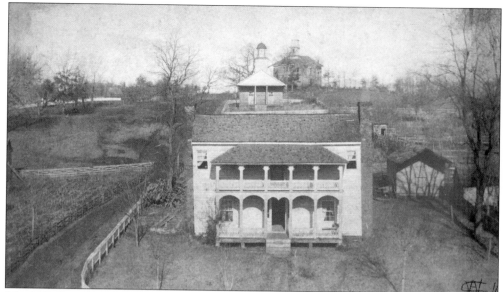

John F. Dobson built this house, the first frame structure in Franklin, in 1826. The original plan was two rooms upstairs and two downstairs. By 1910, when W.A. Curtis shot this photograph, the house had been expanded. The structure visible immediately behind it is the First Presbyterian Church, and behind it is the old Franklin High School. The Dobson house, which had several later owners, was razed in October 1938.

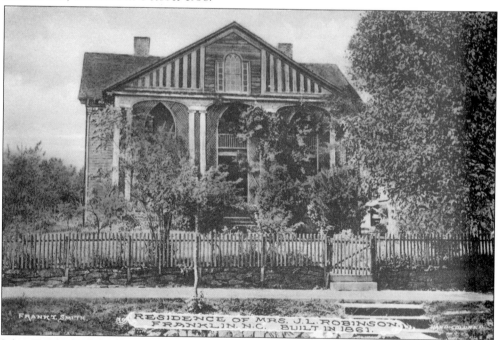

Julius T. Siler built his home, Dixie Hall, shortly before the Civil War. On May 14, 1865, the last organized detachment of Confederate forces in the state surrendered here to Lt. Col. George W. Kirk. Later, Siler's daughter Alice and her husband, Lt. Gov. James L. Robinson, lived here. Dixie Hall was demolished in the early 1970s to make way for the present county courthouse. (Barbara McRae.)

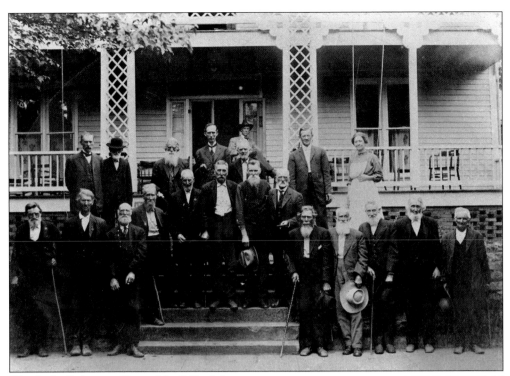

Charles L. Robinson Camp, No. 947, of the United Confederate Veterans Association, was organized in Franklin in 1897. The camp hosted the annual Confederate Veterans Reunions, which were a highlight of the decades that followed. When this image was captured, probably in the 1920s, the old soldiers' numbers had dwindled and the survivors were showing their age. The group gathered for their portrait at the Munday Hotel on Main Street.

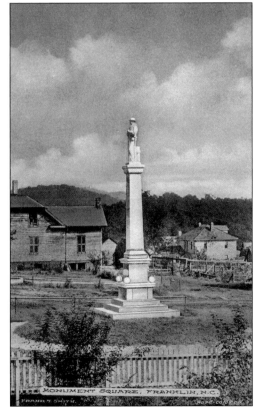

In 1903, Maj. Nathaniel P. Rankin led a drive to erect a Civil War monument in Franklin, assisted by members of the seven Confederate companies formed from Macon County. The marble statue, carved in Italy, cost $600; the base, made of Georgia marble, cost $1,650. The 1909 dedication was attended by the governors of North and South Carolina. The parcel the monument occupies is now called Rankin Square. (Barbara McRae.)

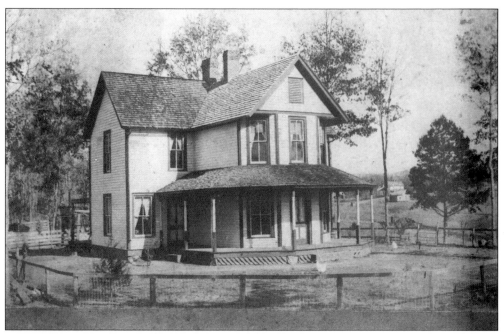

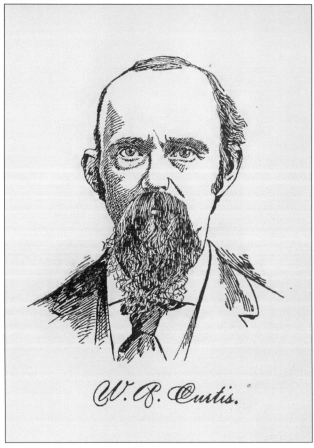

W. A. Curtis.

William Asbury Curtis moved to Franklin about 1888 from Rabun County, Georgia. He purchased the *Franklin Press* from its founder, Thomas Jefferson Christy, and served as its publisher and editor until his death on March 1, 1910. He built this home in west Franklin and farmed there, in addition to his duties at the newspaper. Curtis championed progressive causes and was a strong voice for education, business, community improvement, and tolerance. His writing was often impassioned and frequently sprinkled with wit. Curtis was active in the United Confederate Veterans Association, wrote histories of the war, and helped establish the Confederate monument. The portrait sketch was made to illustrate "The Golden Dawn," the address he gave to the Confederate Veterans Reunion in 1899. (Sketch published by the print shop of the *Franklin Press*, 1899; digitized by the Internet Archive, 2013.)

The Junaluskee Masonic Lodge No. 145 is the oldest fraternal organization in Macon County. The group met above the Julius Siler store on Main Street until 1870, when the first lodge building was completed. Over the years, the old structure served the community as a school, library, and church as well as a fraternal lodge. It was replaced by the present brick structure in 1955.

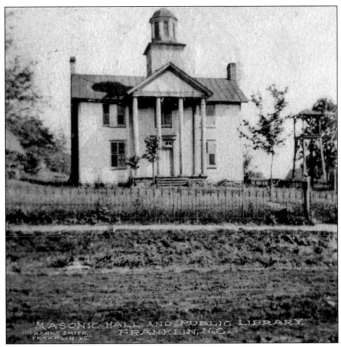

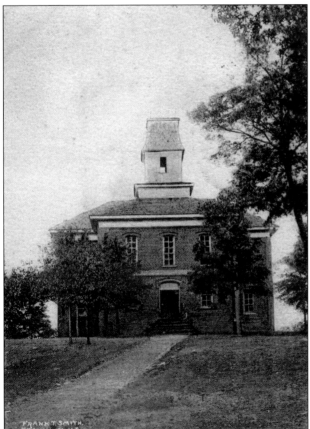

Built in 1887 as the Franklin Academy by the Methodist Church, this structure became Franklin High School in 1891. The two-story building with a bell tower was assembled with handmade bricks in a modified T-plan. The Italianate Revival style is reflected in the extensive corbelling and hood molds. This structure was later converted to an inn, operated as The Franklin Terrace, and is listed in the National Register of Historic Places.

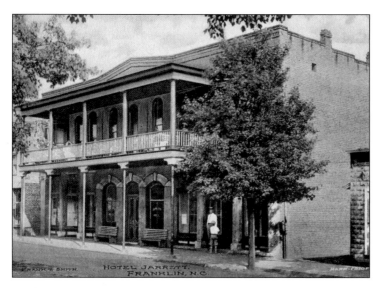

The Jarrett Hotel was among the buildings damaged by a major fire in downtown Franklin on March 27, 1894. After the fire, Main Street business owners moved from frame construction to brick and concrete, giving the town a more modern appearance. The rebuilt hotel likely incorporated parts of the earlier structure, particularly the basement. (Barbara McRae.)

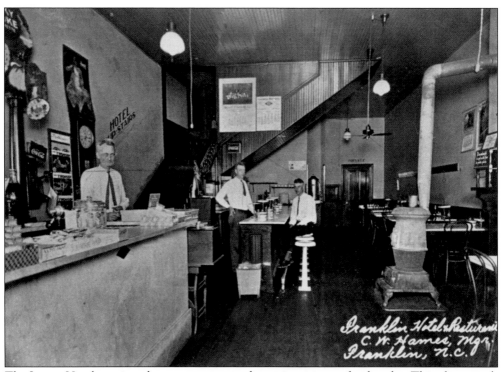

The Jarrett Hotel continued to serve guests under various owners for decades. This photograph shows the lobby of what was then the Franklin Hotel and Restaurant, with C.W. Hames as manager. Guest rooms were upstairs. The building, one of the oldest on Main Street, is still standing, with businesses occupying the two lower levels.

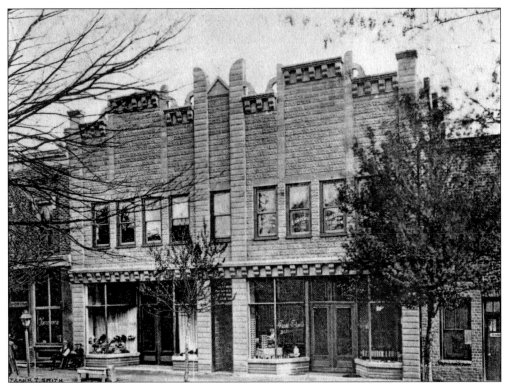

In 1908, the Moore-Benbow building was erected on part of the downtown section destroyed in the 1894 fire. J.T. Moore opened a store in the east side, and Frank T. Smith moved his drugstore down the street to occupy the west side. The Robertson & Benbow law offices were upstairs. (Barbara McRae.)

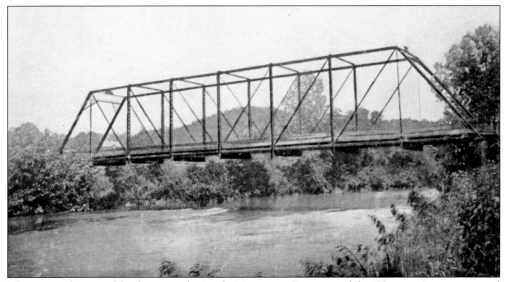

The original covered bridge over the Little Tennessee River stood for 55 years. It was operated as a toll bridge, first privately, then as part of the Great Western Turnpike. In 1890, the state built the iron bridge shown in this image. It served until it was replaced during the 1930s by the Works Progress Administration.

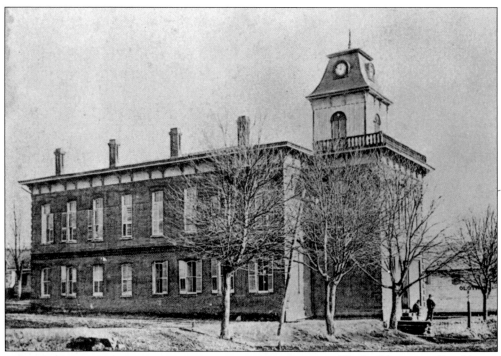

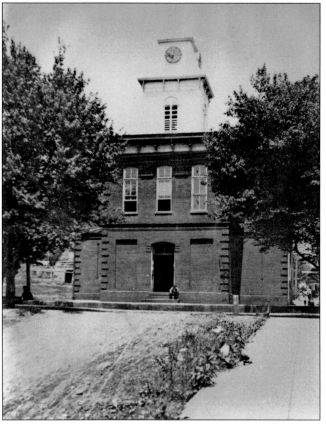

The building most Franklin folks call the "old courthouse" was designed by William Gould Bulgin and constructed by John B. Davis in 1881 for $8,900. It replaced the original 1829 brick structure, which cost roughly half as much to build. Macon County's second courthouse was a two-story building with a board-and-batten cupola rising from the roof of a projected pavilion. Like its predecessor, it stood in the center of the public square. The courtroom also provided a venue for public gatherings of all kinds. After being condemned as unsafe by successive grand juries, the courthouse was demolished and replaced in 1972. The historical clock later found a home in the Clock Tower, built in the shape of the courthouse cupola; it forms the centerpiece of a public garden in a portion of the original square.

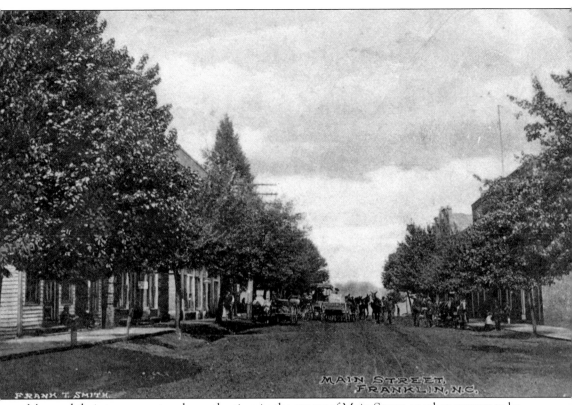

FRANK T. SMITH

MAIN STREET,
FRANKLIN, N.C.

Men and their teams meet and pass the time in the center of Main Street on what appears to be a quiet afternoon in old Franklin. This photograph was taken in the early 1900s. The sight of a utility pole rising above the trees on the left side hints at the changes to come.

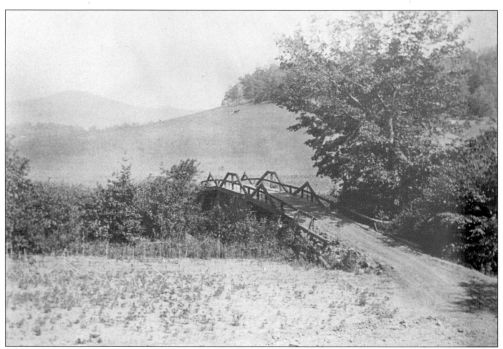

Phillips Bridge, built near the old ford on the Little Tennessee River, leads to rural Clarks Chapel. This part of Franklin was purely bucolic in the early 1900s, though a boom of sorts was just around the corner. In a few years, the Tallulah Falls Railroad would bring tourists and industrial development.

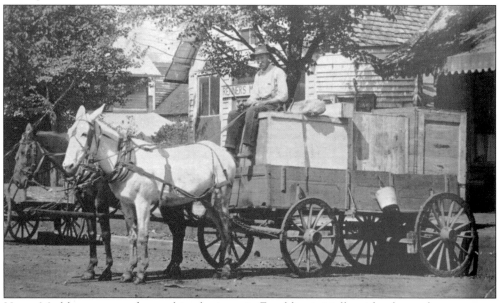

Harve Mashburn operated a trucking business in Franklin, initially with a horse-drawn wagon, seen here, and later with a delivery truck. He is shown in front of Sloan Brothers Store, which made a name for itself by delivering orders to the customer's door. Sloan's began in a small brick building, which was later enveloped into the Scott Griffin Hotel. The store remained at the same location for 23 years.

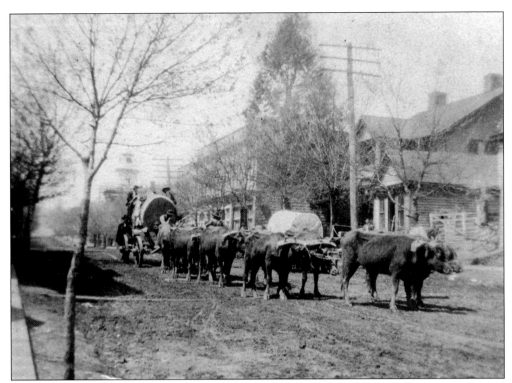

A team of oxen haul a massive tree trunk down Main Street. Though Macon County was covered in forests, a lack of transportation options made logging a challenge. Portable sawmills and the arrival of the railroad would change all that, but at the time this photograph was taken, there were few ways to get timber to market.

Hauling a heavy boiler to a mine in Cowee required plenty of muscle power and coordination, with mules and oxen called into play. Locals came out all along the route to watch the spectacle. This image shows the muddy streets and wooden sidewalks in town; conditions on the rural route to the mine were much worse.

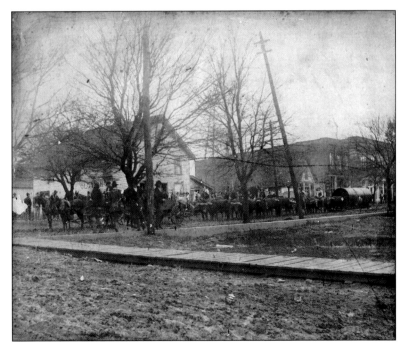

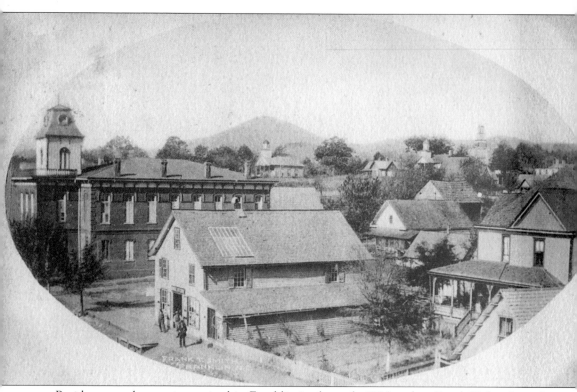

Residences and stores intermixed in Franklin in the early 1900s, when Frank T. Smith made this image. Trotter's Store, an important business of the era, is at center. The old courthouse is at left. Trimont Mountain rises at center back. First Presbyterian Church stands just below the peak of Trimont; to the right is St. Agnes Church, and behind it, the spire of Franklin High School. (Barbara McRae.)

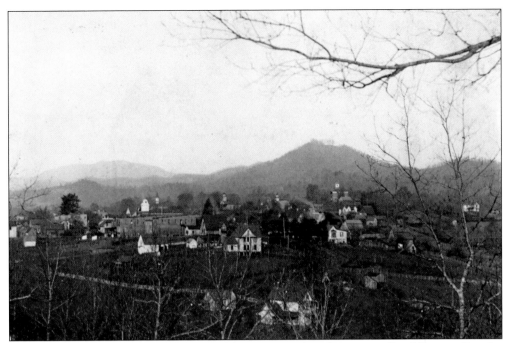

Visitors in the early 20th century invariably commented on how pretty Franklin was. Popular postcards views captured the charms of the town from surrounding hills. This image, looking northwest, shows the white tower of the courthouse at left. The spires Franklin United Methodist Church, First Presbyterian Church, the Junaluska Masonic Lodge, and Franklin High School are clustered at right, below Trimont Mountain. (Barbara McRae.)

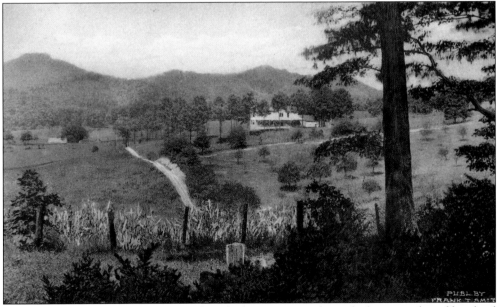

This scene, taken from Franklin United Methodist Cemetery, shows the long stretches of farmland that made up west Franklin in the early 20th century. One tombstone is visible in the foreground. The mountain at upper left is Trimont, which was a popular destination for locals and tourists for hikes and picnics. (Barbara McRae.)

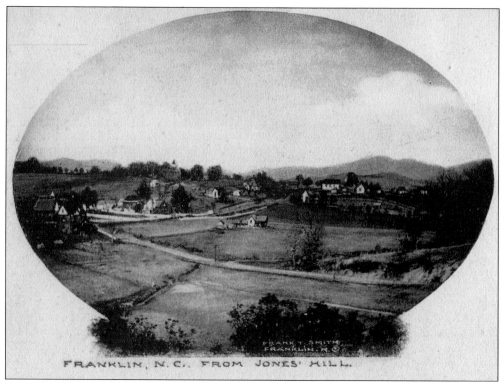

FRANKLIN, N. C., FROM JONES' HILL.

Around 1900, Frank T. Smith produced a popular line of postcards with oval-shaped images. This one was taken looking east toward the Cowee range. When this photograph was taken, Franklin had only 335 residents living in 66 households. The two roads that meet at left in this picture are Main Street, which goes toward town, and the old Georgia Road, now Maple Street.

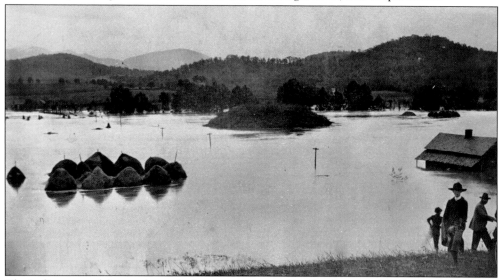

The Indian mound, haystacks, and a house are swamped by floodwaters of Little Tennessee River in July 1916 after the area was hit by successive tropical storms on July 5 and 6 and then again on July 14. All previous records of rainfall were exceeded. This photograph shows a line of utility poles marking the road, which ran on the north side of the Nikwasi Mound. (Barbara McRae.)

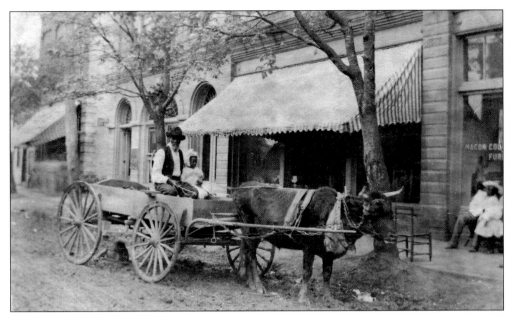

A man and child park their steer-driven wagon on Main Street about 1907. The structure with the arched windows directly behind the wagon is the brand-new bank building, which added an elegant note to the streetscape. Benches and chairs on the sidewalk in front of Macon County Furniture invite people to linger.

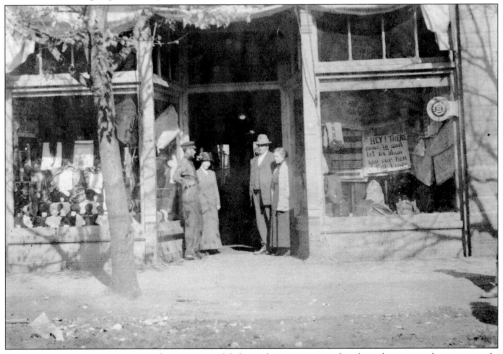

Trotter's Store was a center of commercial life and community for decades, providing not only essentials, but also luxuries and fashionable clothing. The circular sign informs shoppers that the store carries shoes from J.K. Orr, an Atlanta firm, while a hand-lettered sign in the window invites, "Hey! There come in and let us show you our new Fall Line."

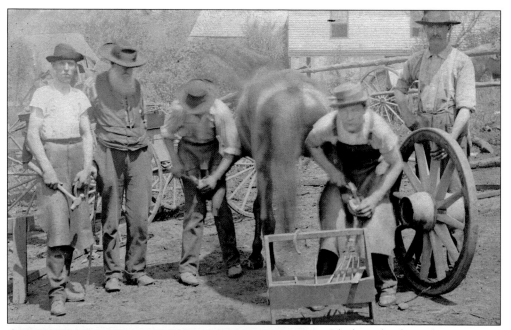

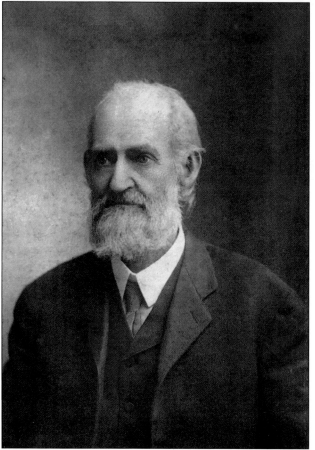

Blacksmiths shoe a horse at the Bulgin shop, which was located at the corner of Main Street and Harrison Avenue. At far left is George Bulgin; his brother Randolph is next to the horse on the left. The Bulgin brothers were the sons of William Gould Bulgin, a native of England, who came to Franklin after the Civil War and put his skills as a builder and designer to work. He built two National Register properties—the Albert Swain Bryson house (1877) and St. Agnes Episcopal Church (1888)—and designed the second Macon County courthouse in 1881. He also created a dynasty of skilled craftsmen: three generations of his descendants earned a name for their metalworking skills, including grandson John Bulgin and great-grandson Randolph Bulgin.

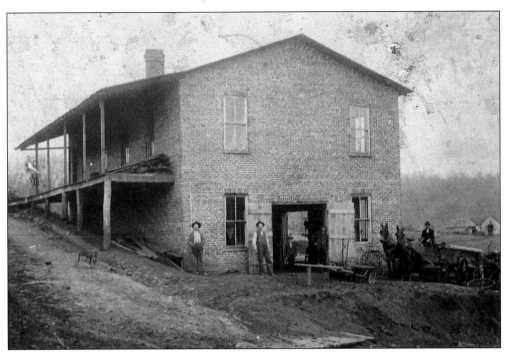

Jacob Palmer and his partner, Charles Avery Cabe, kept a blacksmith shop near where Palmer and East Main Streets meet. Palmer's sons Frank and James were also involved in the business. The shop served the needs of an era based on horsepower and hand tools and produced wagons and buggies for local families.

Early photographers roamed the countryside with their heavy equipment, taking images of people at home. Subjects posed on the porch or hung a coverlet on a wall for a backdrop. The results offer priceless insights into the lives of ordinary people like this family with their homemade but charming outfits, the barefoot boy, the little sisters with their dolls, the swaddled infant, and a proud mother.

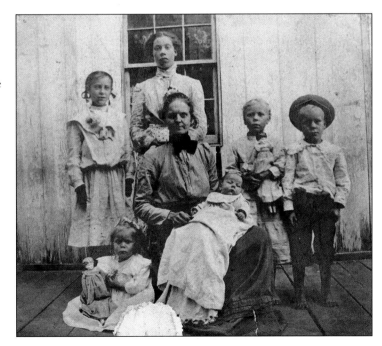

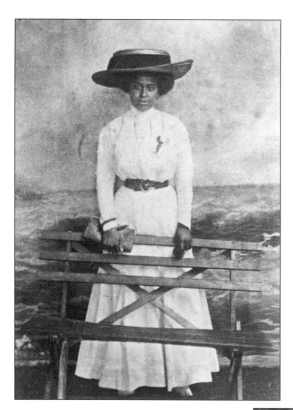

Ola Stewart Thomas (1883–1980) visited one of Franklin's studio photographers to have this elegant portrait made. She may have had it made at Trotter's Store, where her husband Eugene Thomas worked. The couple also kept a farm. Ola had deep roots in Macon County; her ancestors included both free African Americans and slaves.

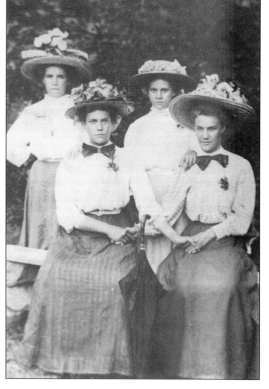

Whether women lived in town or in the country, they recognized the importance of fashion. Beginning in the late 19th century, Franklin offered the services of experienced milliners, who sold the latest hats or redressed lady's hats to bring them up to date. These four young women might have just come back from a trip to town, eager to show off their new creations. (Lawrence Wood collection, Macon County Historical Society.)

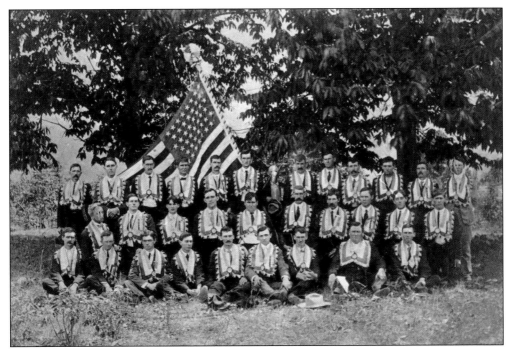

The late 19th and early 20th centuries were the era of the lodge meeting for Franklin and Macon County. These men were members of the Junior Order of United American Mechanics, popularly called the "Juniors." The national organization provided "benevolence," chiefly burial insurance, and members found support and comradeship at their meetings.

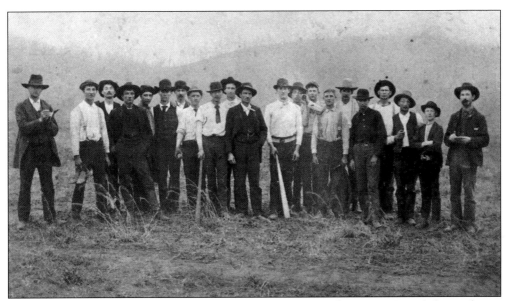

W.A. Curtis photographed the Franklin baseball team on April 10, 1899. From left to right are A.W. Horn, Jess Angel, Charlie Addington, Green Angel, Fred Oliver, Jim Lyle, Ham Jarrett, Dr. Fred Siler, Lee Crawford, Will Sloan, Bob Williams, Dr. W.A. Rogers, John Fulton, John Neville, Frank Williams, Charlie Cabe, Charlie Wright, Gus Setser, Thrent Angel, Dr. Bob Bell, and Judge Fred Moore. (Oscar W. Ashe collection, Macon County Historical Museum.)

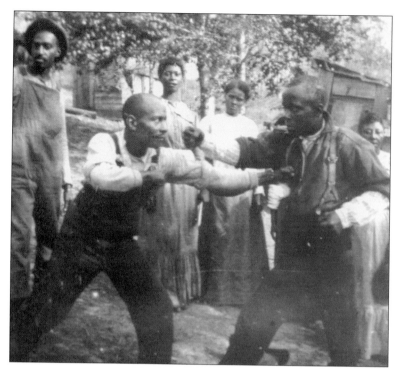

The manly art of boxing enjoyed a heyday in the early 20th century. Contests were often widely promoted and offered contestants an opportunity to win prize money and make a name for themselves. These two pugilists are fighting a bare-knuckles match, but their postures show a sense of style and, perhaps, training. Their identities are unknown.

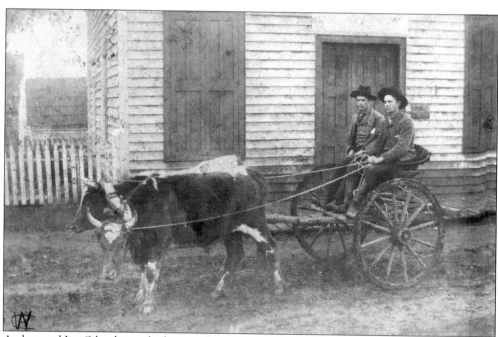

Arthur and Jim Siler drive a little steer-drawn buggy around town about 1886. These young men were the sons of Albert and Joanna (Chipman) Siler. The sign on the building behind them advertises "Mail Pouch" tobacco. This type of transportation was a dirty business; note the mud clinging to the wheel rims. Jim died in 1892.

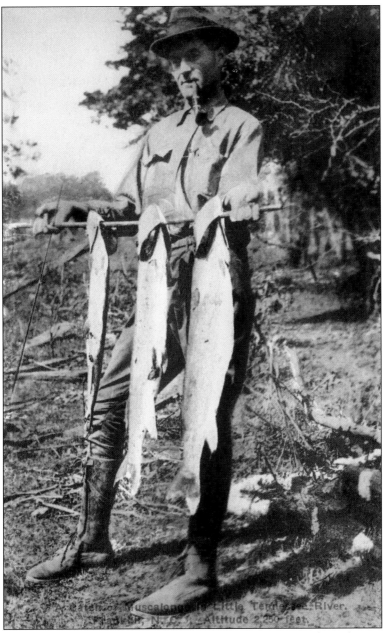

Macon County's beautiful mountain streams drew sports fishermen from the earliest years. Visitors often stayed at an inn or boarded with a mountain family, rented a horse, and hired a guide to take them to the best fishing spots. The Little Tennessee River near Franklin offered the remarkable opportunity to take a muskellunge, "tiger of the waters," which was usually associated with more northerly rivers. The name of this large pike is French Canadian in origin. Smallmouth bass, found in the Little Tennessee and its tributaries, were another favorite, prized both for eating and sport. Nineteenth-century travel writers touted the romance and adventure of the scenic Appalachian wilderness and helped stimulate tourism. This postcard, featuring a lucky angler with three massive muskies, was clearly designed to lure other hopeful sportsmen to Franklin to try their luck. (Barbara McRae.)

31

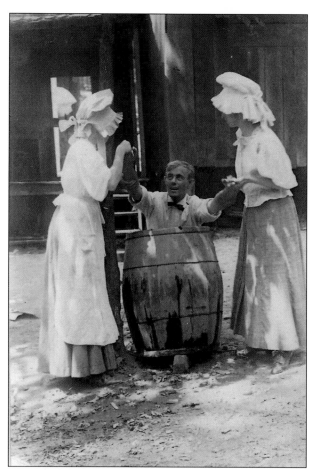

Bonneted young women are either dunking a young man or rescuing him from a barrel during the Franklin Follies, a 1904 festival. For the young people of Franklin, it was a chance for high-spirited fun and a friendly competition. The enterprising photographer who took this image advertised his services at "8 Pict for 25¢."

The home of Kope Elias and his family was located where Angel Hospital is now. The photograph shows Kope; his wife, Timoxena Siler; and their six children gathered on the porch. Elias served in the North Carolina House of Representatives and was a friend and vigorous supporter of Pres. Grover Cleveland. Lumberman Andrew Gennett, who rented the house in 1908, remembered it as almost paradise in summer but unbearable in winter.

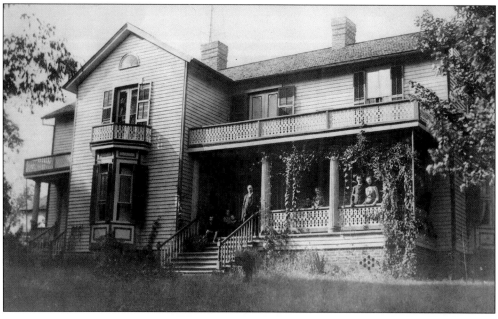

In 1888, Franklin merchant Isaac J. Ashe built a large 10-room house for his family on a 30-acre tract on Harrison Avenue, just a block from downtown Franklin. They planted orchards and a garden and raised livestock. The house is still standing and is one of the oldest structures on its street.

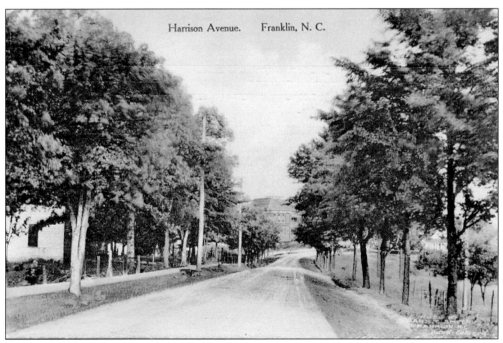

Isaac Ashe planted maples along Harrison Avenue, creating a shady and inviting route to the north. It was a civic-minded gesture typical of other leading men of his era. Ashe wore several hats; besides being a farmer and merchant, he served as a US Marshal and a town constable. A few of the trees he planted still survive. (Barbara McRae.)

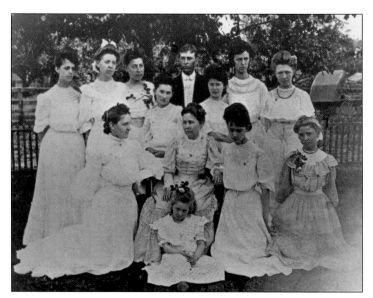

Music teacher Annie Johnston is seated in the first row and surrounded by her students in this c. 1900 photograph. She and her husband, Fred, kept a hospitable house, and she frequently held recitals for her pupils. A graduate of Wesleyan College in vocal and instrumental music, Annie directed the choir at the Methodist church and had a great influence on the musical and social life of Franklin.

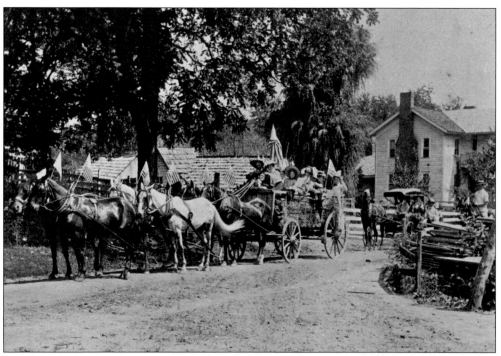

In the days before window screens and air-conditioning, midsummer could become uncomfortable, even in a mountain town. Some families moved to higher elevations for the hottest weeks or months. These Franklin folks are headed to Wayah Bald (elevation 5,331 feet) for the Fourth of July. A camp on Wayah Bald, complete with cabins, provided all the necessities; campers even managed Sunday services, thanks to a visiting minister.

Two

PROGRESS AND CHANGE

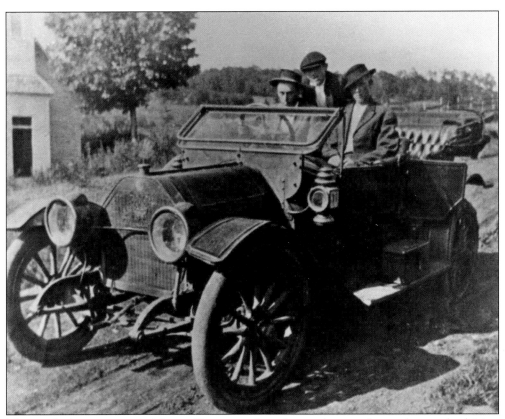

Motor vehicles were rare in Macon County until roads were improved enough to make driving practical. There were just 15 cars in the county in 1914, but by 1934, Franklin had three miles of bitulitchic paving, and businesses catering to cars were beginning to proliferate. These young men taking their car for a ride in the country were on the cutting edge.

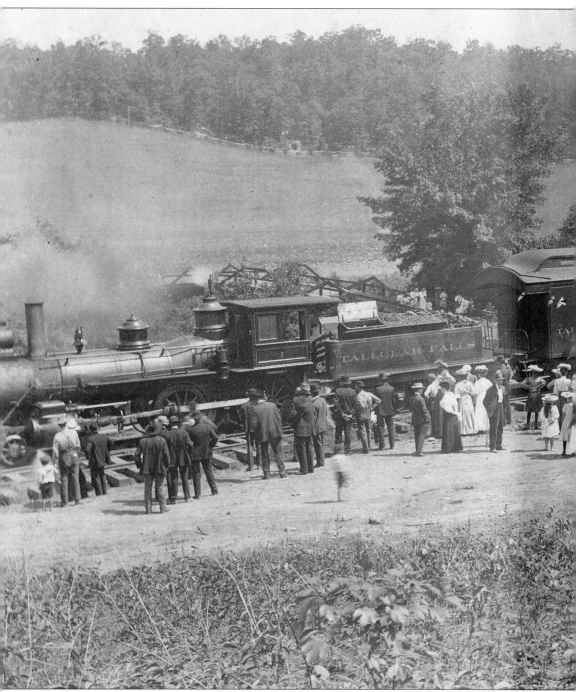

The Tallulah Falls Railroad (TF), a spur line of the Southern Railroad, came to Franklin in 1907, culminating decades of civic longing. On that perfect summer day, the entire town turned out, with everyone in their best outfits. As exciting as it was, however, problems arose almost from the beginning, and plans to push the line beyond Franklin failed. The rail line's timing was poor, for the automobile's rise was at hand. Demand for rail transport was destined to decline; by the 1940s, the railroad ended passenger service. The editor of the *Franklin Press* commented that

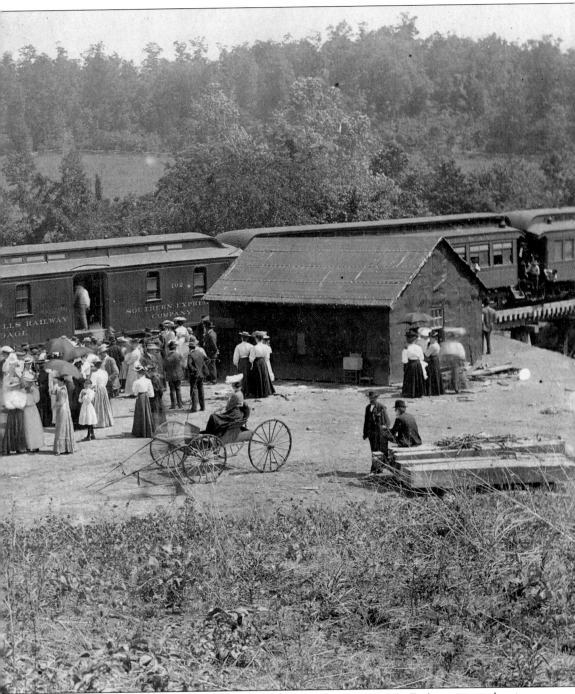

the TF helped dig its own grave by hauling materials to build new roads. Early on, it gave logging a boost and created a flash of progress, but that soon played out. The line hauled freight until 1961, when it shut down after years of financial woes. It had one last moment of glory before it was gone for good: In 1955, Walt Disney used the line for his film *The Great Locomotive Chase*, a Civil War thriller starring Fess Parker and Tab Hunter.

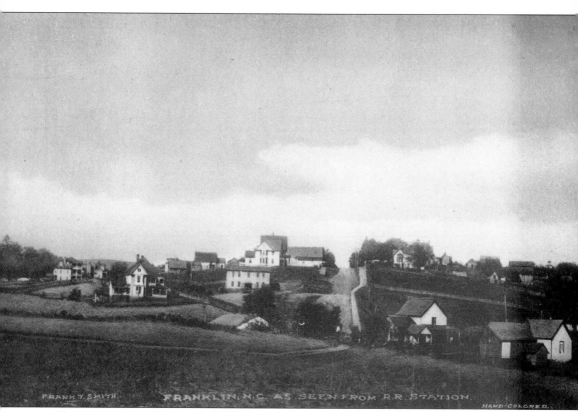

FRANK T. SMITH. FRANKLIN, N.C. AS SEEN FROM R.R. STATION. HAND-COLORED.

The little Franklin Depot gave local photographers a new twist for their postcard scenes. Frank T. Smith published this hand-colored view of "Franklin, N.C. as seen from R.R. Station." The sight must have been a welcome one for tourists visiting from the south, for good food and gracious hospitality waited at the top of Town Hill. (Barbara McRae.)

Men with work horses and shovels contemplate a job behind the old courthouse while two children watch from the steps of a store that advertises "Oliver Plows." The nearby parking lot has one bicycle and a nice collection of early cars. The project likely involved the creation of a parking lot for more automobiles. Franklin's world was changing.

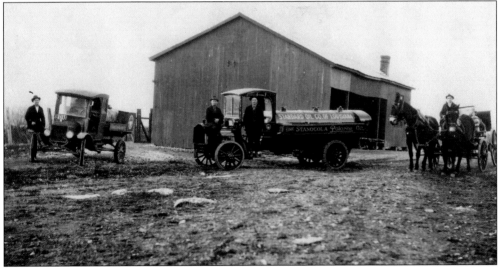

Standard Oil Company of Louisiana filled Franklin's growing demand for petroleum products. Customers came to the lot to fill their oil tanks. Some, like the man at right, hauled their tanks in mule-drawn wagons. In 1928, Standard Oil built two filling stations and a bulk storage plant in Franklin. The plant, used to store gas and oil, cost around $50,000 and was considered the most modern in the state.

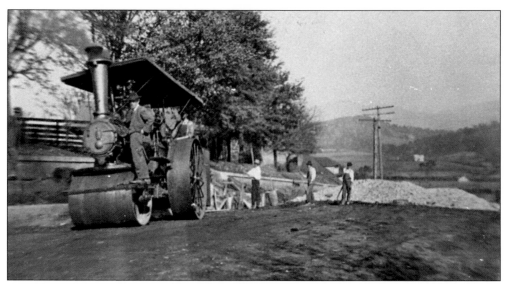

An early grader smooths the surface of a road, preparing it for the automobiles that would soon arrive. The better the roads became, the more cars the county saw; the more drivers, the louder the clamor for better roads. For Franklin promoters, good roads meant tourists. Efforts to attract visitors by the Franklin Board of Trade, and later the chamber of commerce, began to ratchet up. (Charles Morgan.)

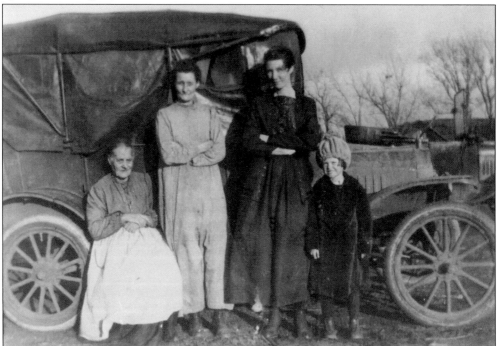

The family car was a source of pride for young and old, and women were as thrilled with the contraptions as the men were. Cars meant independence. Franklin grew as rural residents became dependent on their new vehicles, taking more trips to town to purchase goods and obtain services. Little country stores closed, but other opportunities opened, including jobs repairing, selling, filling, and tending the marvelous new machines.

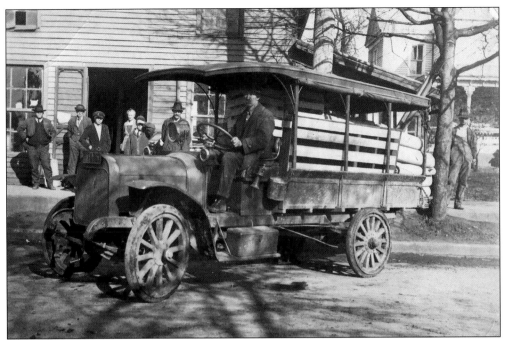

Harve Mashburn (1863–1925) drew gawkers when he backed his delivery truck up to the curb by Trotter's Store. Judging from the onlookers' interest, this must have been a maiden voyage for the vehicle, which replaced his old two-horse wagon. Mashburn had an ace in the hole: his son Earl, a mechanic, was living with him at this time.

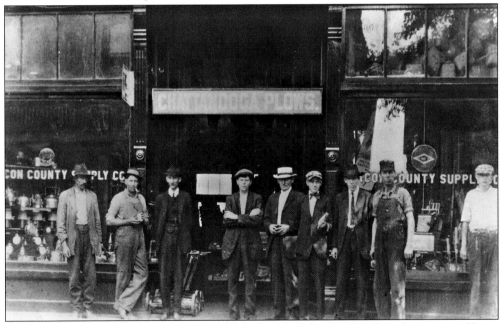

Macon County Supply Company was established in 1909 by Gus Leach and associates. Harve Bryant and Lyman Higdon bought the business in 1932, and it continued as a fixture on Main Street for generations, eventually outgrowing its building and spawning new family businesses, which are still serving the community.

Franklin, N.C. Macon N.C.

 (City) (County) (State)

I have this **23rd,** day of **March** , 19 **25** , purchased fr

Joines Motor & Tractor Co of **Franklin, N.C.** , herein called Ven

 (Write Dealer's Name) (City) (State)

Make **Ford** ; Body Type **Touring** ; Motor No. **11355196**

The terms of which purchase and sale are as follows: **25%** cash and **75%** in deferred payme
Title to all of the above, together with all equipment and accessories heretofore attached or hereafter to be attached,
mains in Vendor or his Assigns until the balance of $ **392.16** , which I am due thereon is paid

 (Total Sum of Deferred Payments)

which I agree to pay in full within twelve months from date of purchase, according to the tenor of an agreement execu
contemporaneously herewith.
Signed, sealed and delivered, in the presence of:

Mary E. Jaines

Notary Public County, Ga. x _S. A. Munday_ (L

S.A. Munday, one of Franklin's leading citizens, bought a four-cylinder, 22.5-horsepower 1925 Ford Touring Car from Joines Motor & Tractor Company on March 23, 1925. Munday paid $130.84 down and financed the rest in 12 monthly installments of $32.68. The entire transaction, including the loan and registration, was handled on this single slip of paper, front and back. Joines's wife Mary, who signed as notary, was one of many women entering the workforce then. (Barbara McRae.)

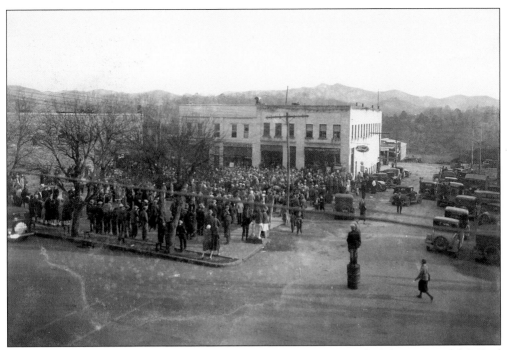

The excitement of the crowd is palpable. The occasion was the arrival of the new Model A Ford in Franklin for a special, three-day showing. An estimated 1,000 people came to Joines Motor & Tractor Company on the public square for the 1928 unveiling, an incredible showing given that the population of the entire county was less than 13,000.

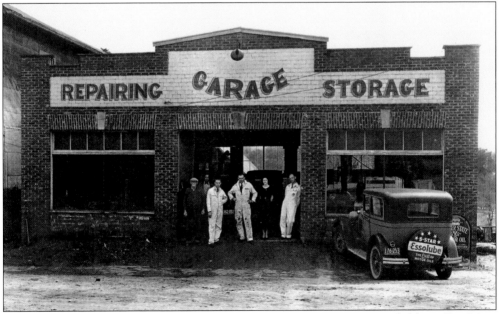

An early garage offered repairing and storage of vehicles in a neat setup, probably on East Main Street in Franklin. This photograph was taken in 1931 according to the date shown on the license plate. By this time, Macon County had four main highways that made access easy for motorists, whether locals or visitors. (Wayne English.)

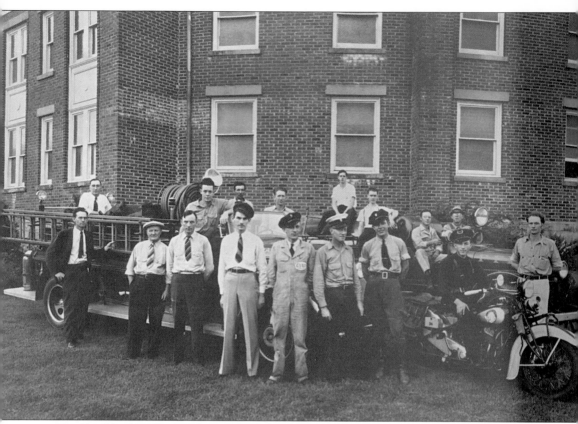

The Franklin Fire Department poses with its new 1937 Chevrolet engine and old Model T (in back). The department had come a long way from reliance on hand reels and carts. From left to right are (first row) George Dean, Arthur Pannell, Truman Moody, Bill Cunningham, John Cunningham, Chief Derald Ashe, Carl Tysinger, C.D. Baird, and Ralph "Red" Welch; (second row) Paul Potts, Lije Grant, Bill Sutton, Jack Sherrill, Bill Porter, Terrell Hoilman, Dick Conley, and Wade Avery.

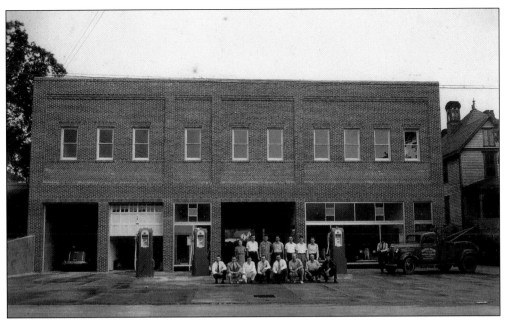

W.C. Burrell came to Franklin from Clayton, Georgia, in the early 1930s and opened a Chevrolet dealership on Main Street at the top of Town Hill. The business grew, encompassing a Texaco filling station and a garage in this large facility, which housed apartments on the second floor. The Franklin Town Hall is now located on this lot. (Wayne English.)

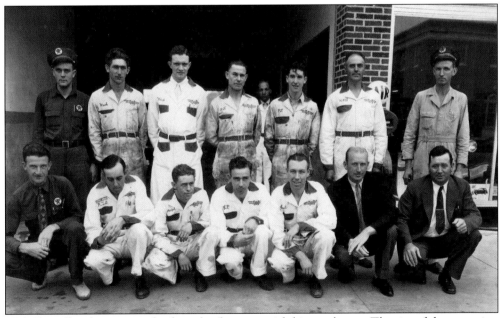

W.C. Burrell is the man on the far right, first row, with his employees. The size of the operation is a testimonial to the economic impact of the automobile. Burrell later expanded into other ventures and became one of Franklin's leading citizens, serving as mayor for more than 12 years. (Wayne English.)

A combination of factors, including improved transportation and rural electrification, led to the development of a large dairy industry in Macon County, which eventually involved about 50 farmers. The foremost of those was A.B. Slagle, who also served as sheriff when he started his dairy in the 1920s. He purchased a local creamery in Franklin and made it into a bottling plant, processing milk from his own and other farms. The milk was trucked from outlying dairies to the creamery for processing, and the bottled product was delivered to customers' doors. Unfortunately, change caught up with the dairy farmers; by the end of the 20th century, all had shut down their businesses. (Barbara McRae.)

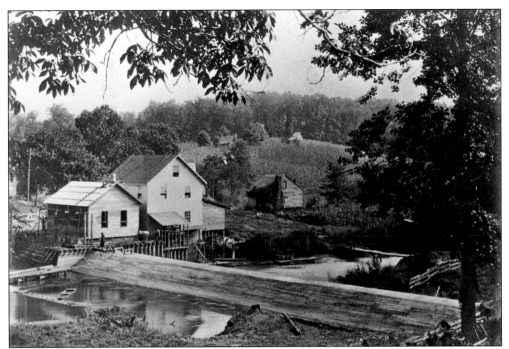

The old Roller Mill on Cartoogechaye Creek began as a mill operated by J.R. Siler, an original settler of Franklin. His family ran the mill through much of the 19th century. In 1891, new owner C.J. Harris made it into a roller mill, which was considered a great advance at the time. Henry O. Cozad bought the mill in 1909 and built it into Franklin's first hydroelectric plant. (Barbara McRae.)

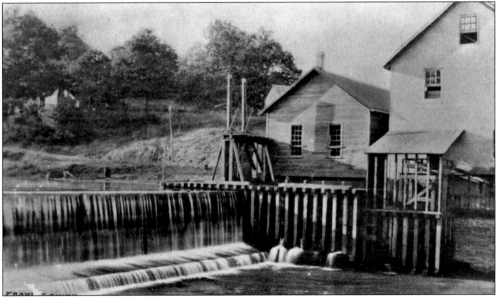

Another view of Franklin's first power plant is seen above. Franklin Light and Power Company served the town's needs from 1909 to 1925. Old-timers recall that when Angel Hospital scheduled an operation, Dr. Furman Angel would call to alert the plant. Operator Herman Childers would see that enough water was built up in the reservoir to keep the lights on. (Barbara McRae.)

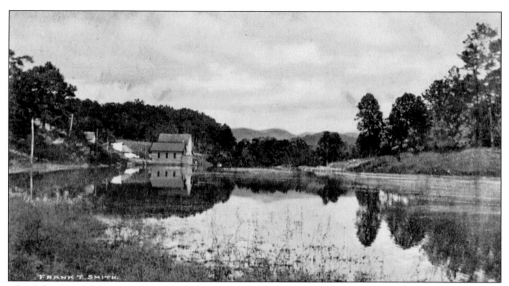

The lake formed by the Cozad hydroelectric plant was small but picturesque and was used as a recreational facility by local people. After the town bought the Franklin Light and Power Company in 1926, the old plant continued to produce enough electricity to supply an ice company at the site. Today, all traces of the mill and dam are gone, but the street is still called Roller Mill Road. (Barbara McRae.)

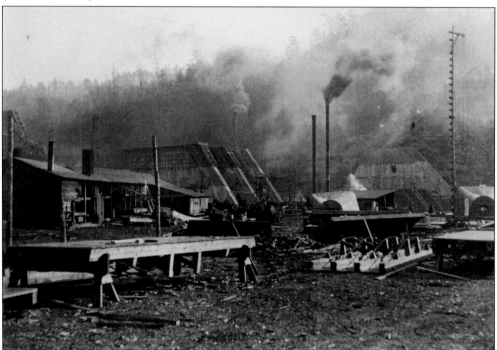

Local organizers formed Lake Emory Company in 1923 to construct a hydroelectric dam on the Little Tennessee River near Franklin, creating a resort lake and an electric company for the town. Charles Morgan took this photograph of construction at the dam site. It was completed, and the waterways closed on October 8, 1926; the plant went live on November 17. A $300,000 bond issue financed the project.

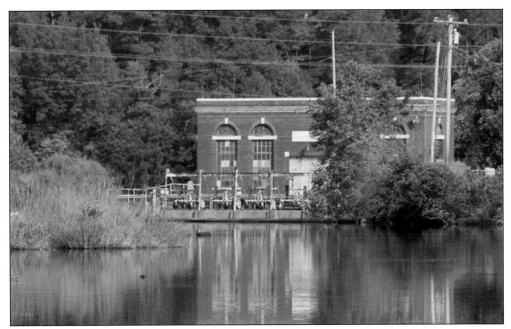

The powerhouse at Lake Emory is a handsome, Renaissance Revival building with multilight segmental-arch windows. Its attractive appearance evokes the optimistic spirit with which it was built. The town fully believed the lake created by the dam would bring a wealth of tourism and the hydroelectric facility would bring in so much revenue that town taxes would become unnecessary. Silt and the Great Depression put an end to those dreams.

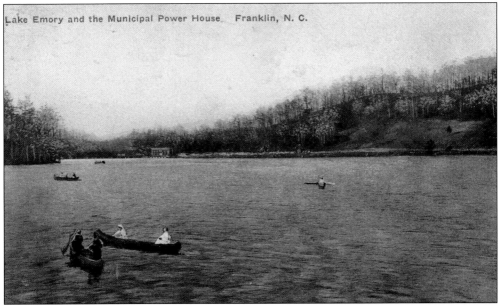

Lake Emory and the Municipal Power House Franklin, N. C.

Canoes ply the waters of Lake Emory in this idyllic scene, taken soon after the municipal powerhouse began generating. Things were not so rosy financially. The town sold the plant, and it went through several hands and had fallen in disrepair before reverting to the town in 1933. Nantahala Power and Light bought the system later that year, after voters agreed, 285 to 14, to allow the sale. (Barbara McRae.)

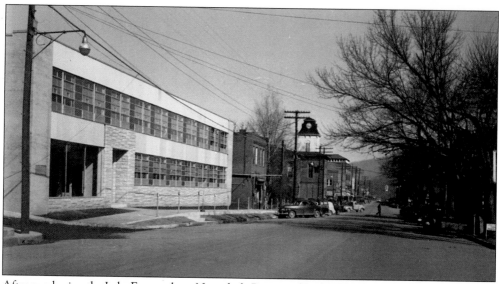

After purchasing the Lake Emory plant, Nantahala Power and Light Company moved its headquarters to Franklin. The next decades were busy ones, with an active program of rural electrification and the construction of several large hydroelectric facilities in the region. In 1952, the company constructed a new headquarters building, seen at left. It now houses county offices.

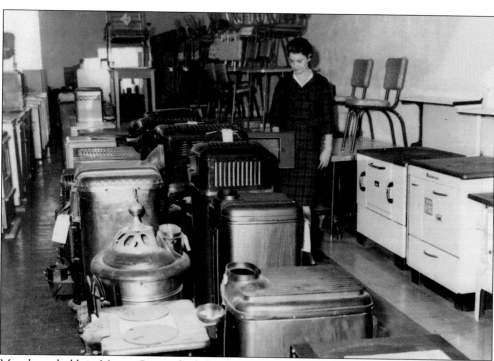

Most households in Macon County had electricity by the early 1950s, but conversion to all-electric homes took time. In 1955, when this photograph was taken, wood was still important for heating and cooking, especially for rural residents. Electric appliances were revolutionizing housework, however. Washing machines and refrigerators were in high demand.

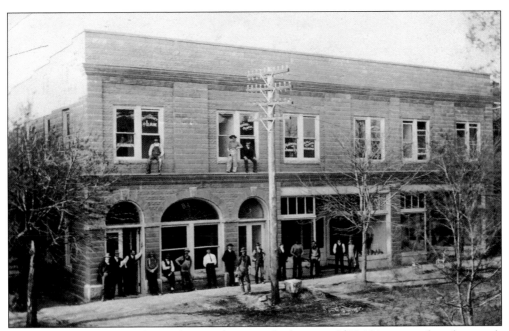

Macon County had no banks until 1903, when town leaders raised $10,000 in capital stock, enough to form the Bank of Franklin. Three years later, Macon Bank opened, moving to this handsome new building in 1907. The institutions merged in 1911 under the name Bank of Franklin. George A. Jones was the first president.

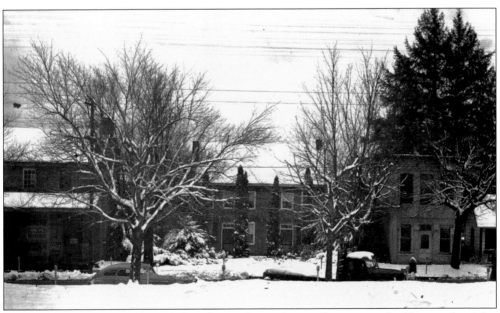

Citizen Bank incorporated in 1913 and moved into the small, two-story building at the right. Like many financial institutions, it suffered reverses during the Great Depression but survived by merging with the Bank of Franklin in 1930. This building and the two structures to the left— the Siler Store building (far left) and the Munday residence—were later razed to make way for Macon Savings and Loan, now Macon Bank.

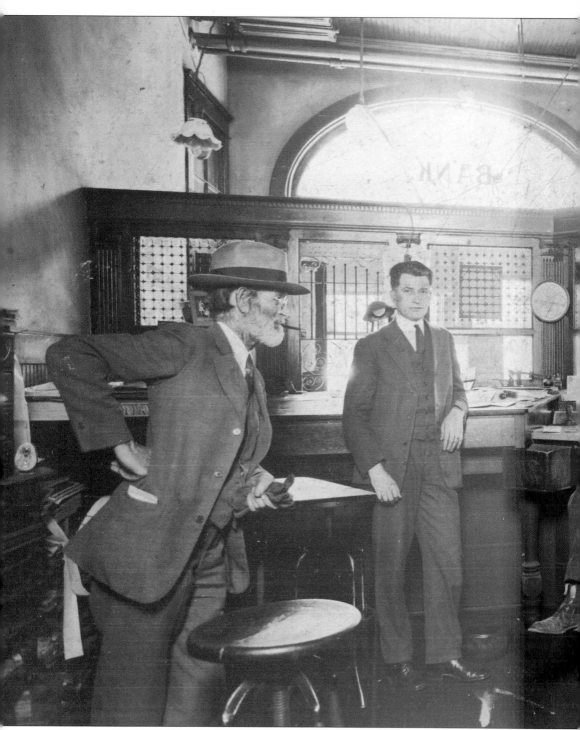

Chairman Dr. Samuel H. Lyle, standing at far left, confers with staff in the work area of the Bank of Franklin. Longtime clerk Henry Cabe is second from left, facing Lyle. The bank went through several mergers and survived the Great Depression after closing for four months, thanks to heroic efforts of the board and the cooperation of depositors. The bank also survived a devastating fire

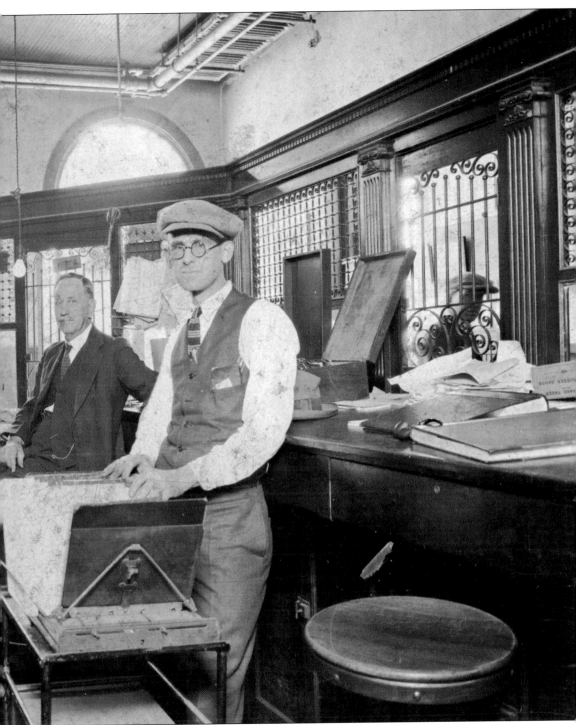

that destroyed a block of downtown Franklin in 1940. It went on with business with scarcely a blink and soon rebuilt. It later merged with First Union and then merged with Wachovia, which later became Wells Fargo. It is still doing business at the same location.

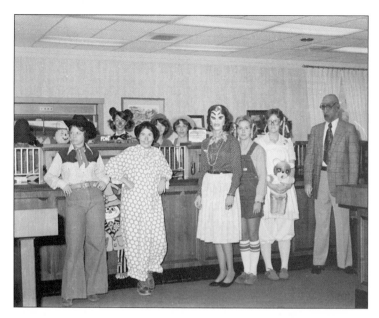

Employees of Macon Savings and Loan get into the spirit of Halloween in this 1980s photograph, taken in the building they occupied from 1964 to 1985. The bank was established as Macon Building and Loan Association in 1922 to encourage home ownership and personal savings. In recent years, the institution became Macon Bank and expanded beyond Macon County. (Barbara McRae.)

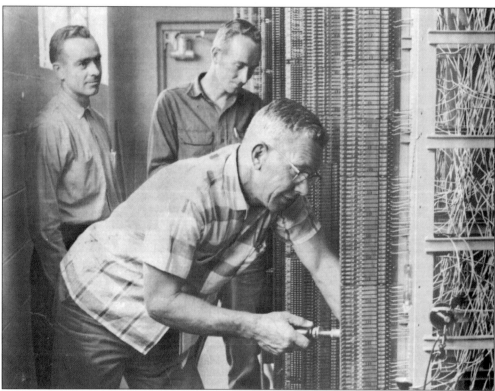

Franklin's telephone service began through the efforts of pioneers such as Samuel Kelly, who started Franklin Telephone and Electric Company in 1904, and his sister Lassie, who took over after his death in 1907. Western Carolina Telephone Company bought the firm out in 1924. By 1955, there were 936 customers in Franklin. Here, from left to right, Harley Carpenter Jr., Neville Wooten, and Carl Tysinger work on an early telephone exchange system.

The Weeks Act of 1911 authorized the purchase of public lands for timber production and watershed protection. Thousands of acres were purchased in Macon County under the provisions of the law. The Nantahala National Forest, with headquarters in Franklin, was established in 1920 to manage these lands. Today, the office oversees 134,000 acres, nearly half of Macon County, from this building on Sloan Road. (Nantahala Ranger Station.)

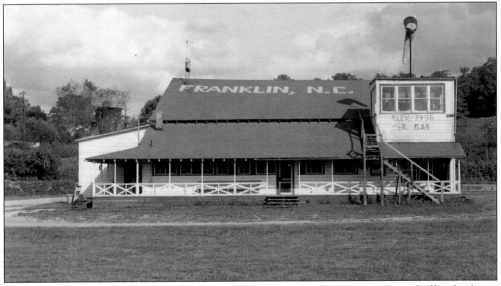

Two young barnstormers brought the first plane into Macon County in 1921 and offered rides to daring residents. Seven years later, Thomas W. Porter and Charles Morgan cleared a strip near the river for the county's first landing field. That served until an airport was built just upstream. It included this comfortable frame building with an observation tower and a café. The present airport opened in Iotla Valley in 1970.

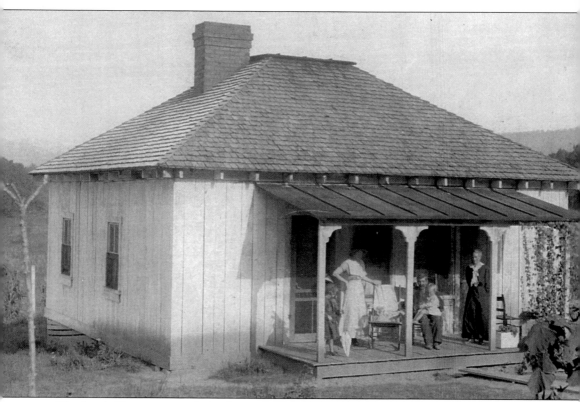

The Jacobs' house, a neat bungalow, was one of those built at Bonny Crest. The subdivision began at Wayah Street, one of the roads created by the development. Bonny Crest covered a large territory that stretched from the Tallulah Falls Railroad right-of-way to the Georgia Road and included such interior streets as Pauline and Louise Avenues.

Joseph Ashear, an Arab immigrant, came to Franklin as a peddler, put down roots, and married. He became a leading merchant and, in 1930, built a new store on Main Street. As this photograph shows, the construction drew curious crowds. The building later housed People's Department Store, a fixture in downtown Franklin for 55 years. People's closed in 2012.

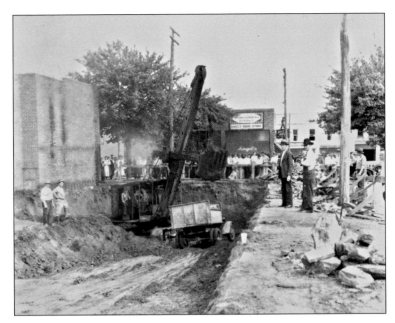

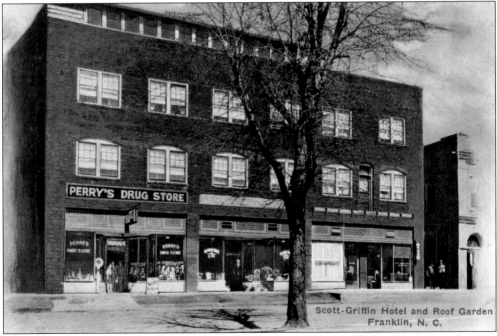

The Scott Griffin Hotel, the tallest building in downtown Franklin, opened to acclaim in February 1927. The town had always had a number of inns and tourist homes, but a first-class hotel was something new. There was even a roof garden for dinner and dancing. The downstairs housed Perry's Drug Store (a successor to Smiths), Sloan Brothers, and the City Barber Shop. (Barbara McRae.)

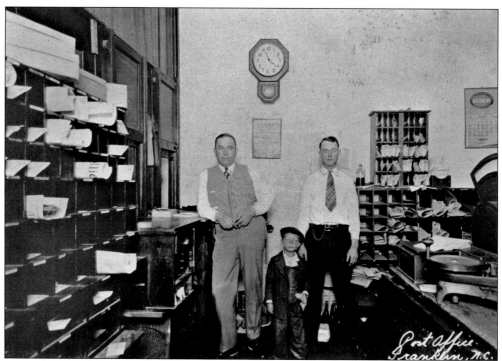

This was the scene inside the old post office on May 1928. From left to right are postmaster Sam Franks, Doyle DeHart, and Ernie DeHart. The office was clearly overcrowded. It was located in a commercial space on Main Street and moved twice more before a large stand-alone building was constructed for it as part of a public works program in the Depression years.

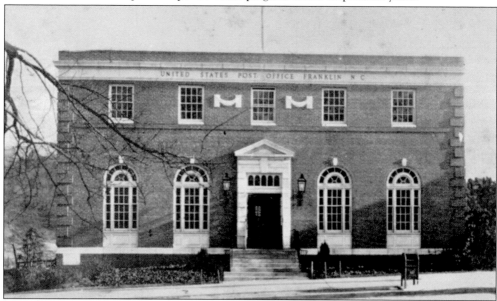

This classic structure on Main Street was the home of the Franklin Post Office for nearly four decades. The county government acquired the building after the postal service outgrew it and constructed a new facility a block away. It now houses the E-911 system and other services. The post office has since moved to Depot Street. (Barbara McRae.)

Three

PLACES IN
FRANKLIN'S HEART

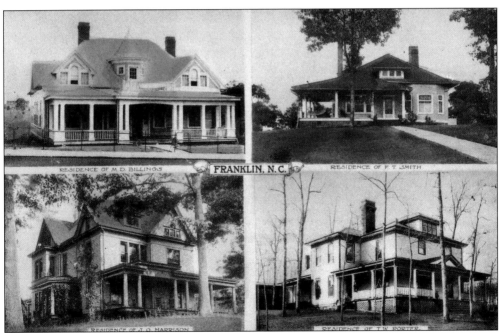

In the late 19th and early 20th centuries, Franklin was home to a prosperous class of merchants and professionals who built handsome homes for their families near the downtown area. Most homes had big porches, well-proportioned rooms, and plenty of space for large families and company. It was a hospitable era. Clockwise from the top left, these residences belonged to the school superintendent, a pharmacist/photographer, salesman/postmaster, and traveling salesman/mayor. (Barbara McRae.)

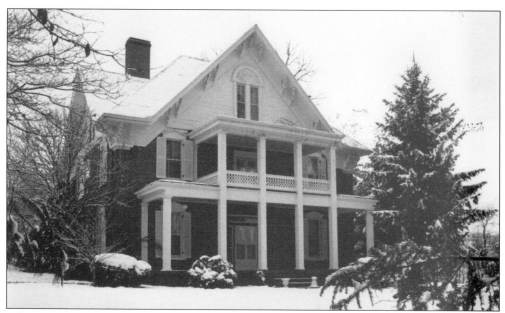

Albert Swain Bryson was a prosperous, largely self-educated, civic-minded merchant who planted the maples that long lined Franklin's Main Street. He built his fine, Italianate-style home in 1877; it was named to the National Register of Historic Places in 1984. Bryson's daughter and son-in-law, Leona and Thomas Porter, later lived in the home. (Hildegard Sandhusen collection, Macon County Historical Society.)

Jesse R. Siler was one of the first settlers of Macon County. He became a large landowner and a merchant with multiple enterprises. He built this home around a two-story Indian cabin soon after moving to Franklin in 1821. The house grew and changed with the generations; it is still owned by Siler's descendants. It was named to the National Register of Historic Places in 1982. (Barbara McRae.)

George Bidwell came from Massachusetts in 1870 to run the Corundum Hill Mine. After the sale of the mine in 1900, he and his wife, Estena, decided to stay in Macon County, where they had many friends. They built this home in Franklin. It was the first house on what was to become Bidwell Street.

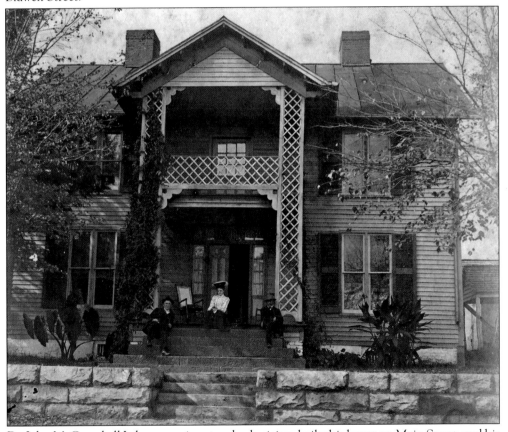

Dr. John McCampbell Lyle, a prominent early physician, built this house on Main Street, and his family lived here from 1856 to 1884. It was later operated as an inn, called the Munday House. The rock wall and steps were built about 1876 by brick mason Pat Gorman. A commercial building that formerly housed Belk Department Store now stands on the site.

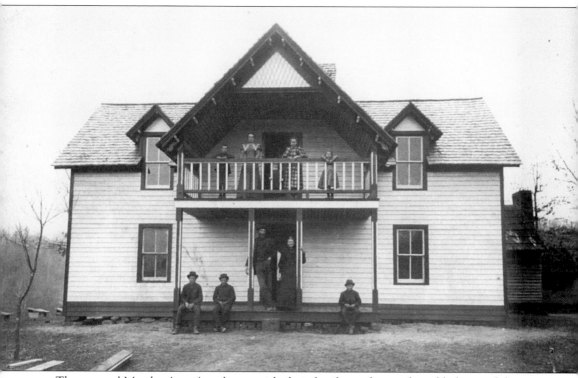

Thomas and Martha Ann Angel pose with their family on the porch and balcony of their new home. Thomas ran a livery service in Franklin and was active in civic affairs, serving six terms as an alderman. Two of his sons, Furman and Edgar, become prominent local physicians and established Angel Hospital. Edgar is seated at left on the porch.

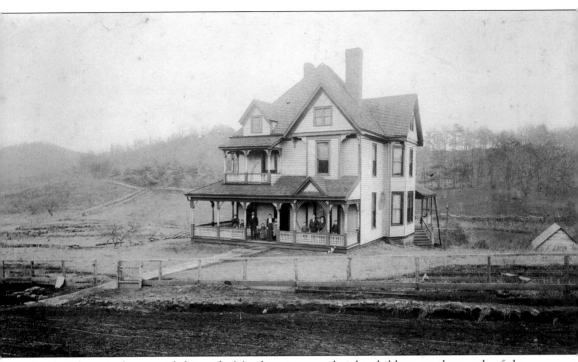

Jacob Palmer is shown with his wife, Martha; sister; and eight children on the porch of the large Victorian house he built near his blacksmith shop about 1899. Martha Palmer died in February 1900, soon after this photograph was taken. Palmer Street, named for the family, is now a major artery for downtown Franklin, but at the turn of the 20th century, this section was largely undeveloped.

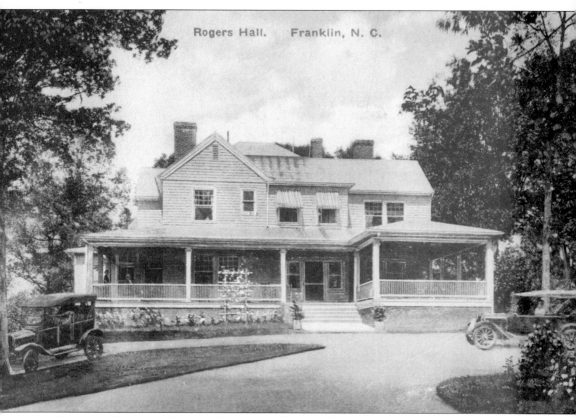

Rogers Hall. Franklin, N. C.

Samuel L. Rogers and his wife, Mamie (Addington), built a nine-room home on Summit Hill, the highest hill in Franklin, in 1898. The Rogers lived here until their deaths, except for several years spent in Washington, DC, when Samuel headed the US Census Bureau. About 1922, they enlarged the house and operated it as an inn, as did subsequent owners. It burned to the ground in December 2006. (Barbara McRae.)

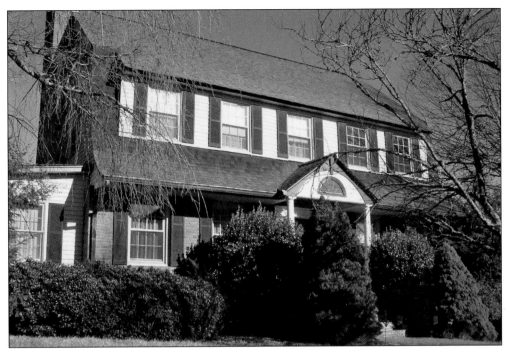

This was the home of Franklin's only female mayor, Eloise Griffin Franks Potts. She and her first husband built this house, a Sears, Roebuck & Company Amsterdam model, about 1925. Later, it was the home of the John Archer family. Archer came to Franklin in 1936 to run the retail department of Nantahala Power and Light Company and later served as its president. (Barbara McRae.)

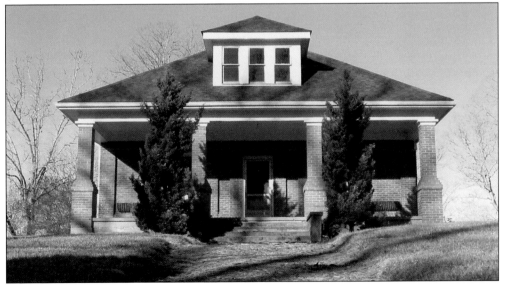

Jessie and Roger Sutton lived in this comfortable, 1920s-era home on Harrison Avenue. Jessie was Macon County Teacher of the Year in 1976–1977, a designation that honored her many years of dedication to the children she taught. As president of the Macon County Historical Society, she led a drive to purchase and preserve the Pendergrass Store, and under her guidance, it became the Macon County Historical Museum. (Barbara McRae.)

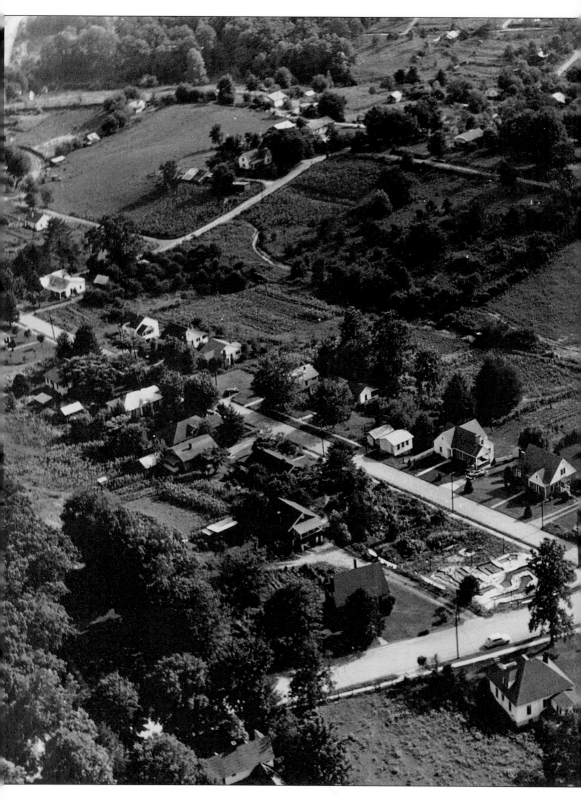

This aerial view, taken probably in the 1940s, shows the quiet neighborhood of Bidwell Street and Harrison Avenue. Lyle Street is visible in the upper left. Curtis Street, where the Christian Science Society is located now, turns to the right off Lyle Street in the upper center. The large building (now Sunset Restaurant) on the corner of Bidwell and Harrison Avenue housed a service station and garage. A Putt-Putt golf course occupied the other corner, and an active mica mine was located on the hill to the right. Mica had great economic importance to Macon County for decades, as it was used for insulators during the expansion of the telephone industry and for many strategic applications during World War II. The mine and the Putt-Putt features are gone now, and some new homes have been built in this area, but otherwise, the scene today looks very much the same. (John Cabe and Laura Shea.)

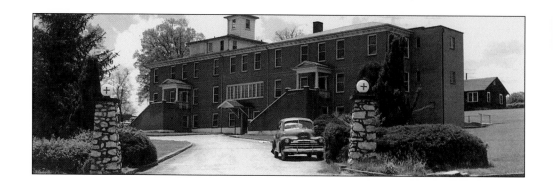

Dr. Furman Angel built Angel Hospital in 1925. He was joined in 1932 by his brother Dr. Edgar Angel. Edgar later bought the facility and greatly expanded it, adding the sections that would become the coronary and intensive care units and the operating suites. Together, the Angel brothers provided 80 years of service to the people of Franklin and surrounding areas. In 1968, the community purchased the hospital following a fundraising drive, and it became Angel Community Hospital. Today, Angel Medical Center is a partner of Mission Health System. (Both, Dr. Joseph Kahn collection, Macon County Historical Museum.)

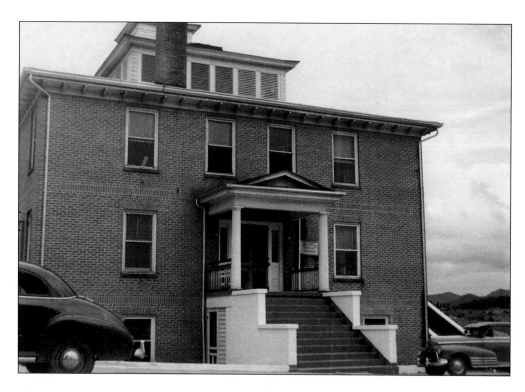

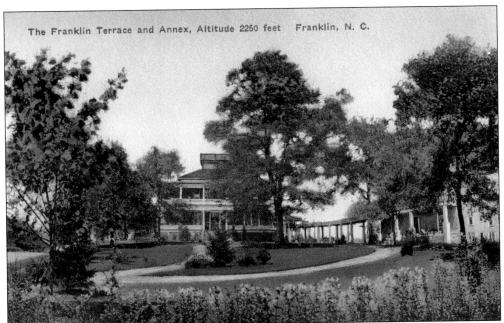

The Franklin Terrace and Annex, Altitude 2250 feet Franklin, N. C.

The Franklin Terrace began its life as the Franklin Academy in 1887. It was remodeled by Mary and Blanche Willis, who purchased it in 1915 and ran it as an inn with 30 bedrooms. It was considered one of the most attractive summer hotels of the area. The postcard view shows the inn with the kitchen annex to the right. The annex burned in 1935. In later years, the main building fell into disrepair and was threatened with demolition, but it was rescued by Pat and Mike Giampolas, shown relaxing on the porch. The Giampolas restored it and opened it as a bed and breakfast. This building was named to the National Register of Historic Places in 1982. (Both, Barbara McRae.)

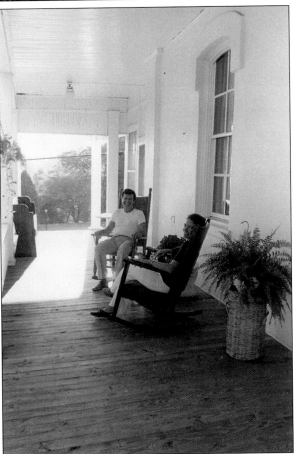

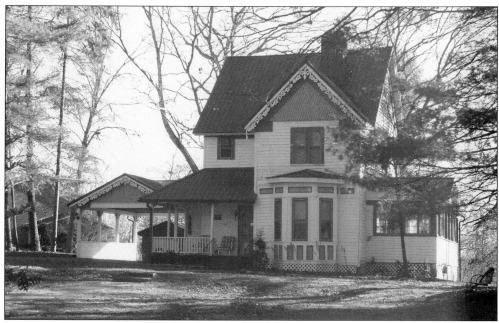

Dr. Samuel Harley Lyle built Franklin's first hospital next to his home on Harrison Avenue (shown above). The hospital attracted patients from throughout the region. His son Samuel Harley Lyle Jr., who, like his father, was a one-time mayor of Franklin, later converted the hospital to a summer hotel. It operated as the Trimont Inn, a place renowned for its fine food, hospitality, and "hot water in every room." The guests enjoying the porch in September 1924 are S.J. Arnold (left), his wife Clara Arnold (center, facing camera), and Mary S. Bennett (foreground). The inn was torn down about 1970; Harrison Garden Apartments now stands on the site. (Above, Barbara McRae.)

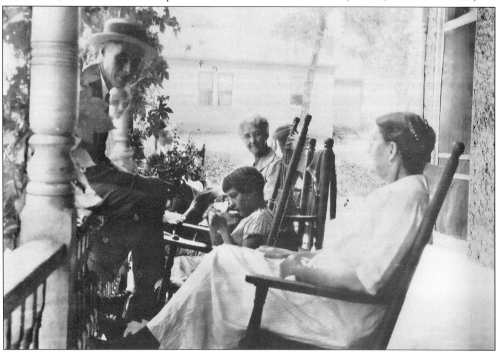

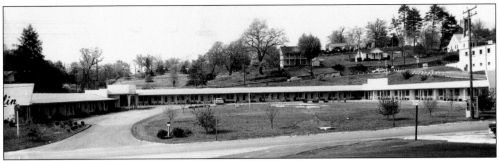

The Franklin Motel was the latest in travel comfort in the 1960s. It was expanded after this photograph was taken, but eventually, time caught up with the landmark, and it was demolished in 2012. The two old residences visible on the hill directly behind the motel are also gone. The building above it at right is the former town hall.

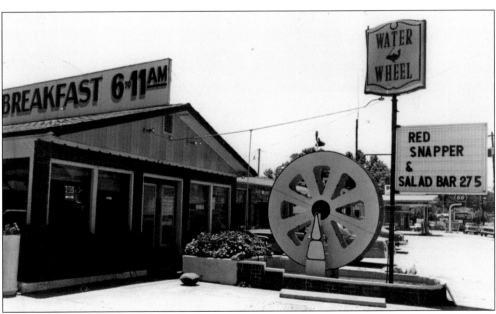

The old Water Wheel Restaurant beside the Little Tennessee River was a popular spot for diners in the 1980s. When the Little Tennessee River Greenway was developed, the property was purchased and made available to Friends of the Greenway (FROGS). It has been remodeled and is now used as a gift shop, café, and offices.

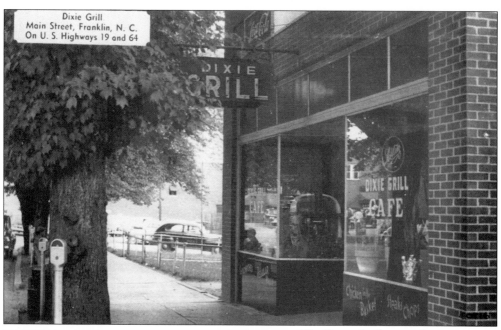

Dixie Grill
Main Street, Franklin, N. C.
On U. S. Highways 19 and 64

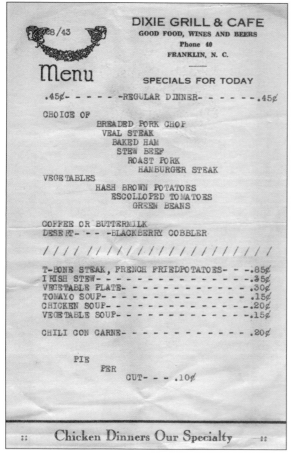

DIXIE GRILL & CAFE

GOOD FOOD, WINES AND BEERS

Phone 40

FRANKLIN, N. C.

Menu

SPECIALS FOR TODAY

.45¢ - - - - - -REGULAR DINNER- - - - - - .45¢

CHOICE OF
 BREADED PORK CHOP
 VEAL STEAK
 BAKED HAM
 STEW BEEF
 ROAST PORK
 HAMBURGER STEAK
VEGETABLES
 HASH BROWN POTATOES
 ESCOLLOPED TOMATOES
 GREEN BEANS

COFFEE OR BUTTERMILK
DESERT- - - - -BLACKBERRY COBBLER

/ /

T-BONE STEAK, FRENCH FRIED POTATOES- - -.85¢
IRISH STEW- - - - - - - - - - - - - - -.35¢
VEGETABLE PLATE- - - - - - - - - - - - - .30¢
TOMAYO SOUP- - - - - - - - - - - - - - .15¢
CHICKEN SOUP- - - - - - - - - - - - - - .20¢
VEGETABLE SOUP- - - - - - - - - - - - - .15¢

CHILI CON CARNE- - - - - - - - - - - - .20¢

 PIE
 PER
 CUT- - - .10¢

:: **Chicken Dinners Our Specialty** ::

The Dixie Grill was a classic American diner, located on Main Street beside the Confederate Memorial. If the image of the restaurant, with the old parking meters and shade trees, isn't enough to produce nostalgia, the menu will do the job, with its complete dinners for 45¢ and a slice of pie for a dime. The building remains, but the meters, trees, and restaurant are long gone.

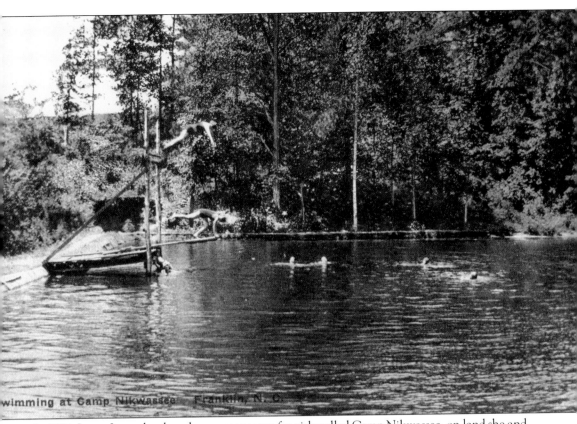

wimming at Camp Nikwassee Franklin, N. C.

In 1924, Laura Jones developed a summer camp for girls called Camp Nikwassee, on land she and her brother Gilmer inherited. She founded her program on "health, character, and joy." The camp could accommodate 40 girls, who enjoyed a season of outdoor activities, crafts, and dramatics. It was highly successful until the Depression forced it to close. (Barbara McRae.)

The original sanctuary of First Presbyterian Church is the oldest brick structure in Macon County. Tradition says the bricks were handmade by slaves on the Little Tennessee River. The church was built in 1854. It is small by the standards of most modern churches, about 50 feet by 36 feet. Its design is an example of a vernacular Greek Revival, temple-form structure. It was listed in the National Register of Historic Places in 1987. (Barbara McRae.)

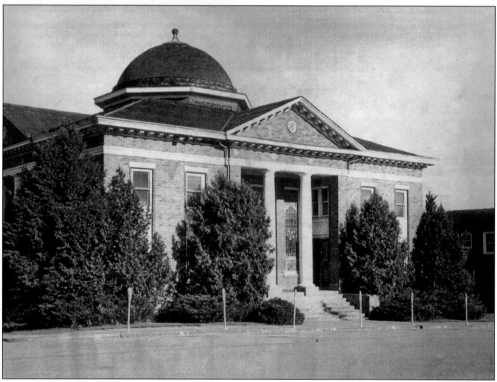

Franklin First Baptist Church was established in 1822 and served as a mother church for others in the area. This church building was constructed in 1920 under the leadership of Rev. W.W. Marr. It was dedicated in 1922. The current sanctuary, with its columned portico and traditional spire, replaced it in 1954.

The story of Methodism in Macon County began in 1820 with two meetings by a visiting minister. As the years passed, services were held in homes of church members until construction of the first church, a weatherboarded log building. The second church, shown at right, was erected in 1860. It was replaced in 1917, but the new church burned soon after it was completed. The congregation immediately began working on a new building. The photograph below was taken soon after its completion. In recent years, an extension was built onto this venerable structure; the old sanctuary is now used as a fellowship hall. (Both, Barbara McRae.)

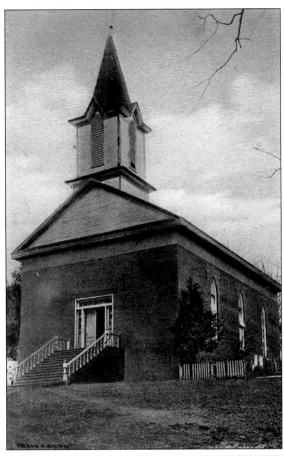

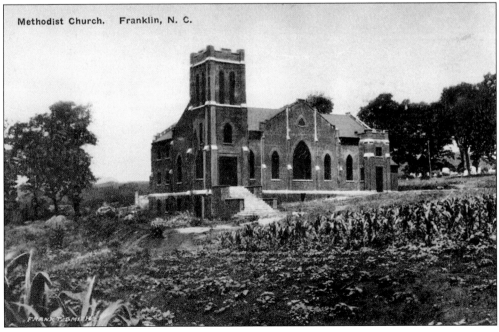

Methodist Church. Franklin, N. C.

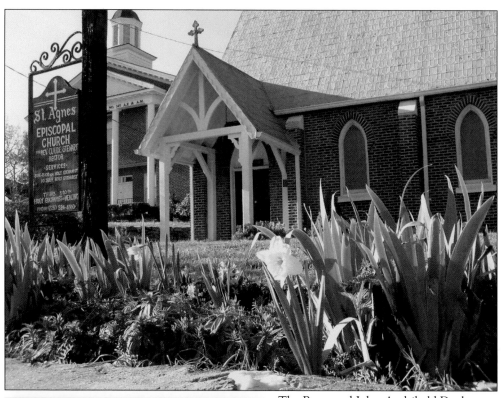

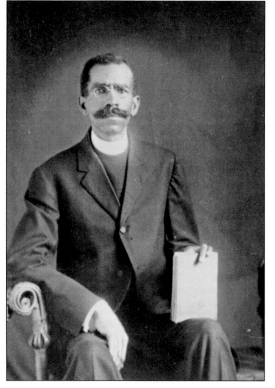

The Reverend John Archibald Deal, an Episcopalian missionary, began work in Macon County in 1877. He founded St. John's Episcopal in Cartoogechaye first, then turned his attention to Franklin, building St. Agnes Church in 1881. The vernacular Gothic Revival building has arched windows with brick hoods along each facade and a conical-shaped roof on the west end. St. Agnes was named to the National Register of Historic Places in 1987. (Barbara McRae.)

St. Cyprian's Episcopal Church and an associated school were established through the efforts of the Reverend John Archibald Deal, who brought the Reverend James Kennedy, shown at left, to Franklin in 1887 to minister to the black community. Kennedy built the simple but beautiful church, which is still standing, and ran the school. He was a skilled carpenter and furniture maker and work produced in his shop was in great demand in the community.

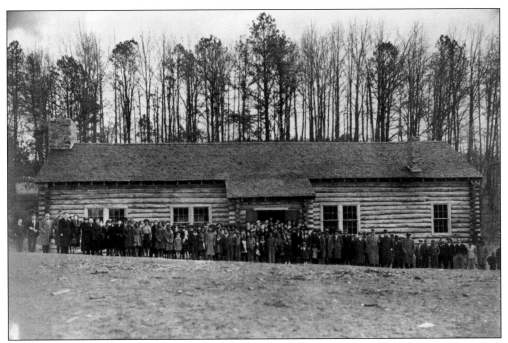

The Frazier Community Center was built by members of the National Youth Administration in the 1930s on the grounds of St. Cyprian's school. It was named for W.W. Frazier, the school's benefactor. This photograph was taken at the dedication. Unfortunately, the center burned in an accidental fire a few years after it opened.

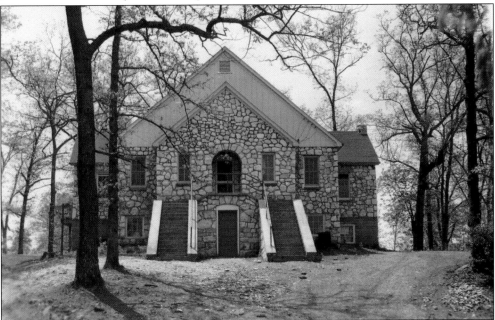

In 1947, Albert Burton Slagle, a former sheriff and dairyman, built Slagle Hall in memory of his son Charlie W. Slagle, who was accidentally killed shortly after returning from service in World War II. The hall has been used through the years by service clubs (including Rotary), the Boy Scouts, and members of the community for events of all kinds.

The Pendergrass Store (1904) was built as a two-story mercantile building by the Reverend J.R. Pendergrass, a Baptist minister. The Pendergrass family kept a dry goods store there until the 1970s, when they sold it to John and Charles Sill for use as an art gallery. The Macon County Historical Society acquired the building for a museum in 1988. It was named to the National Register of Historic Places in 1991. (Barbara McRae.)

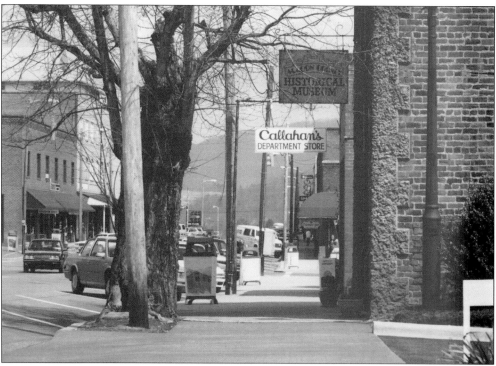

This is the scene looking east on Main Street from the Macon County Historical Museum. The old tree in front of the museum was the last of the maples that formerly lined the street. Local legend claims that politicians once hid bottles of liquor there to pay off voters. Onion Mountain is visible in the background. (Barbara McRae.)

Main Street was decked out with fall decorations in this photograph, taken about 2000. The building at left is the new courthouse, constructed in 1972. The building with the hat-like roof is the old Scott Griffin, now vacant on the upper floors. (Barbara McRae.)

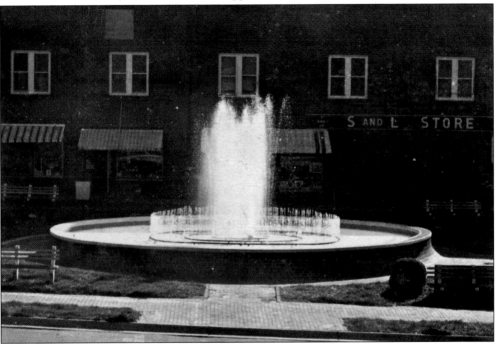

When the old courthouse was removed, the landscaping plan for its replacement included a fountain to serve as a veterans' memorial. It would be the centerpiece of the square across from the new county building. The three-stage fountain with colored lights was finished in December 1973. Maples were planted in the square around it. Eventually, however, the fountain proved too much trouble to keep up and had to be removed.

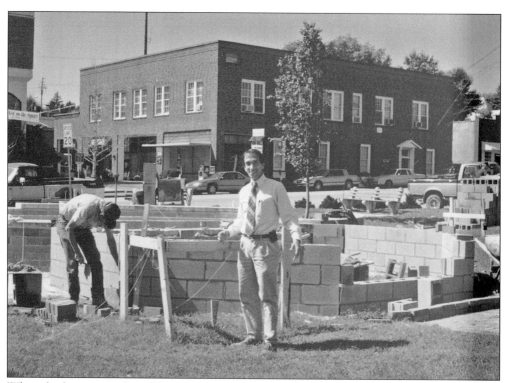

When the fountain in the public square became nonfunctional, the Franklin Main Street program decided to build a gazebo that could be used for public programs on the square. The work was accomplished in 1992 by volunteers with donated materials. Here, Dr. Fred Berger of the Main Street board shows his delight in the progress being made. (Barbara McRae.)

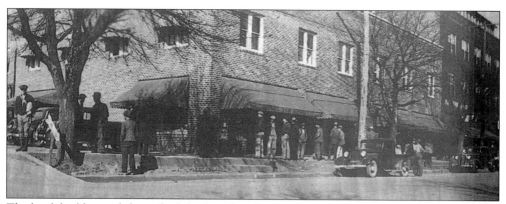

The brick building at left was built by Joseph Ashear in 1930 for his mercantile business. When this photograph was taken, the S&L 5&10 occupied the corner store, next to People's Department Store. A classic dime store, S&L was a favorite destination for visitors and locals into the early 1970s. When it closed, J.C. Jacobs expanded People's into the space. People's closed in 2012 after a 55-year run.

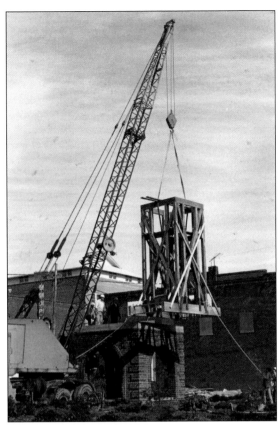

After construction of the new courthouse in 1972, plans surfaced to create a garden area in a parking lot beside the old Angel Drug Store, with a central belvedere structure to contain the old courthouse bell. Ideas continued to evolve. At one point, the Franklin Optimist Club intended to build a gazebo from the old courthouse bricks, with a tower to house the bell. In the late 1970s, the Franklin Jaycees took the lead, constructing a tower that echoed the design of the old courthouse cupola, surmounted with the courthouse clock. The tower and surrounding garden, which is tended by the Franklin Garden Club, have since become a beautiful park and a symbol of the town. The images show the top of the tower being put in place and the tower lit for Christmas.

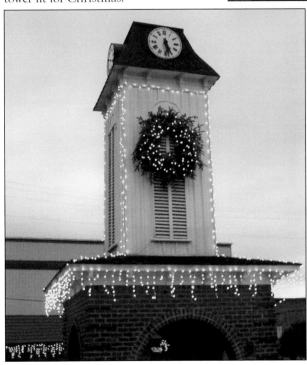

After 54 years in the old Masonic Lodge, the Franklin Public Library moved to this building on Philips Street, next to the county jail, in 1955. The 1,600-square-foot space would be the library's home for the next two decades. In 1971, the name was changed to the Macon County Public Library to reflect the growing patron base. The library has moved twice since then to brand-new, more spacious quarters.

The Town of Franklin erected this building in 1994 on the site of the old Macon Theater and Burrell Motor Company. It originally housed the Scottish Tartans Museum. Later, the Franklin Police Department occupied the downstairs. The building is now home to the town hall. The museum has moved across the street, and the town police have a new building of their own. (Barbara McRae.)

Four

THE PEOPLE OF FRANKLIN

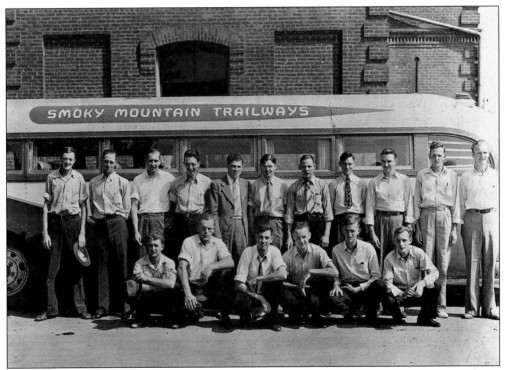

In July 1940, draftees posed in downtown Franklin before boarding a Smoky Mountain Trailways bus to Fort Benning, Georgia. They were among the 1,646 men and women from Macon County who served in the Armed Forces during World War II. At center back is J.C. Jacobs in suit; William Johnson, editor of the *Franklin Press*, stands next to him on the right.

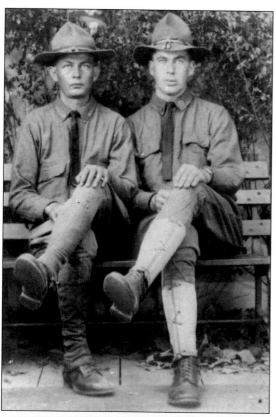

Sylvester Winchester (left) and George Wallace Reece (right) served their country during World War I. About 1,000 men registered for the draft during that conflict; almost half—486—were found qualified and entered the service. Thirteen of those servicemen gave their lives. Returning veterans formed a local chapter of the American Legion. (Barbara McRae.)

The Kelly sisters pursued lives characterized by achievement and public service. Elizabeth (left) became a force in education, first locally and then for the state, where she held several significant posts. Lassie (right) was one of the first women in North Carolina to pass the state bar. She served as a Yeoman in the US Navy during World War I, in the office of Josephus Daniels, secretary of the Navy.

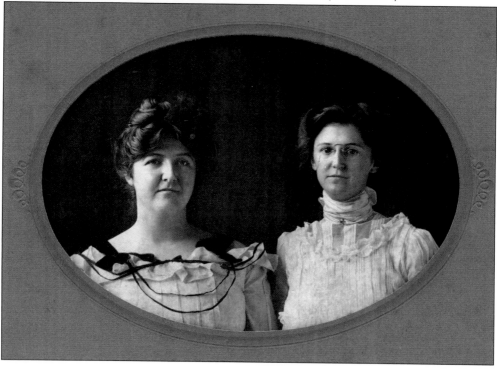

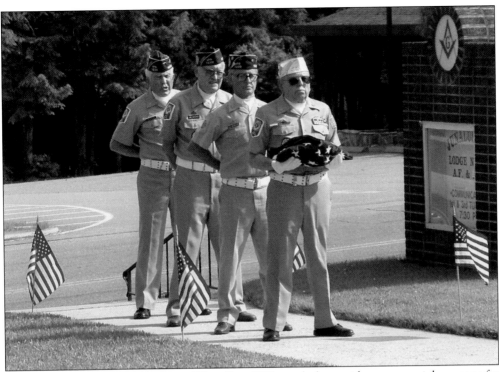

Members of the Veterans of Foreign Wars, Post 7339, regularly provide a ceremonial presence for civic functions, including parades and holiday celebrations. They see to it that veterans are laid to rest with honor and take the lead in patriotic observances, such as Memorial Day services. In these photographs, a VFW color guard prepares to raise the American flag during a patriotic ceremony at the Junaluskee Masonic Lodge and members plan a military funeral. From left to right are (first row) Boyd Lee (Vietnam), Howard Johnson (Korea), and Kenneth Carpenter (Vietnam); (second row) Neil Reindeau (Vietnam) and Bud VanHook (Vietnam).

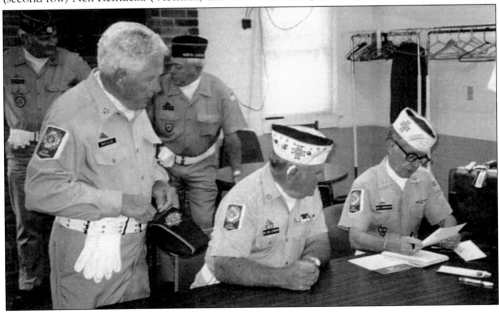

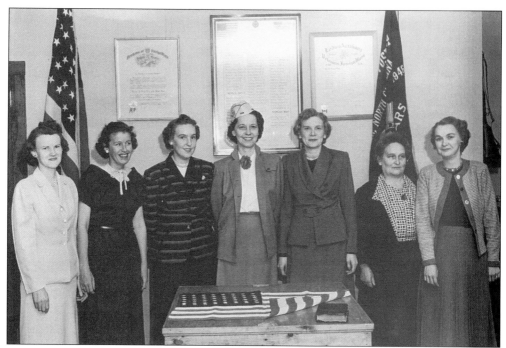

In 1953, the Ladies Auxiliary for Post 7339, Veterans of Foreign Wars installed new officers. From left to right are Mrs. Tom Nelson, guard; Mildred Patton, treasurer; Annie Ray Murray, junior vice president; Lasca E. Horsley, president; Pauline Garrison, senior vice president; Lucille Angel, retiring president; and Katherine Perry, conductress.

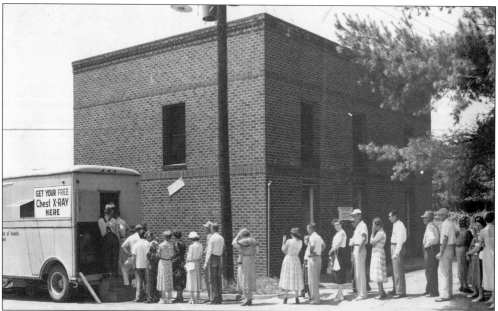

Residents line up for free chest X-rays provided by the board of health in a mobile unit parked in front of the county jail. In the early 1950s, when this photograph was taken, tuberculosis was a major killer. The free X-ray campaign was designed to catch unsuspected cases of the highly infectious disease before symptoms appeared.

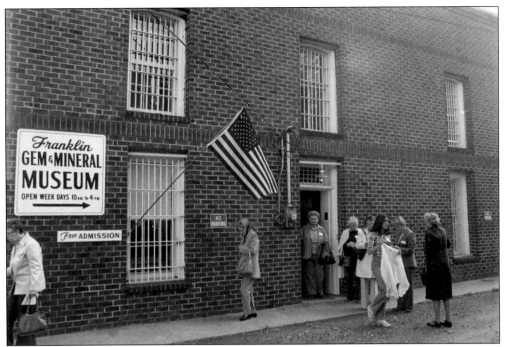

After construction of the new courthouse in 1972, the historic jail building was no longer needed to house prisoners. County commissioners made it available to the Franklin Gem and Mineral Society, which created a unique museum in the facility. Eight rooms are filled with gems and minerals from all over the world in an interesting and unique setting.

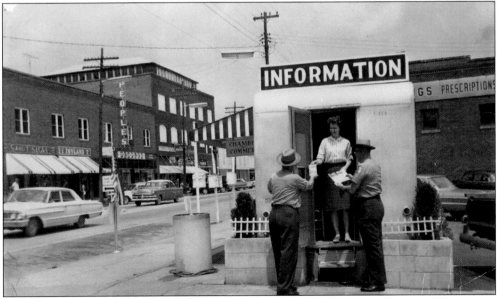

Lasca Horsley hands out tourist information to visitors from the Franklin Chamber of Commerce information booth on Main Street. The chamber later acquired a roomier home on the Georgia Road, which serves as a welcome station for people coming to Franklin. It also hosts several festivals each year, promotes tourism, and encourages a healthy business environment in Franklin and Macon County.

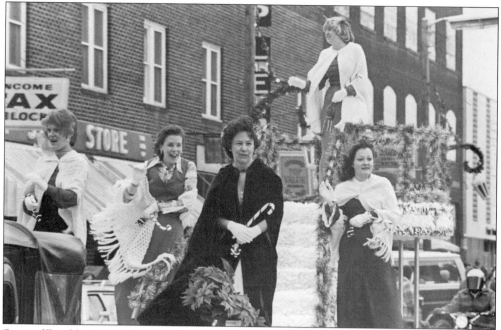

Some of Franklin's young beauties wave to bystanders from a float in the annual Christmas parade, managing to enjoy themselves despite the frigid weather. The parade, which takes place on the Sunday after Thanksgiving, remains one of the highlights of the year and marks the seasonal appearance of Mr. and Mrs. Santa Claus.

Contestants in the 1980 Miss Franklin pageant get help with their hair and makeup before the competition. The event was held at the Fine Arts Center of Franklin High School. The winning Miss Franklin was expected to grace ceremonial civic occasions, such as ribbon cuttings for new businesses, and go on to the statewide competition. (Barbara McRae.)

The Franklin Business and Professional Women's Club, a member of the International Federation, was active in the 1980s. The club's role included recognizing outstanding women, networking, and promoting causes important to women, particularly the drive for an equal rights amendment. In these photographs, members surprise working women in the community who were chosen for recognition as "Woman of the Day" during National Business Women's Week. Above, Franklin Business and Professional Women's Club member Joan Teague pins a corsage on Jean Guffey Farmer at the Franklin Seed Store, the business she and her family ran on Main Street. Below, Suzanne Cunningham Williams surprises Audrey Gibson Ledbetter, a receptionist for optometrist Dr. David Hill Sr. (Both, Barbara McRae.)

Franklin's hairdressers gather at the Macon County Community Facilities Building in the early 1980s to donate their services for charity. The event was broadcast on local radio. The Cut-A-Thon has proven to be a popular and dependable fundraiser, providing financial assistance for worthy causes such as the Hospice House Foundation. (Barbara McRae.)

High Hopes Garden Club holds a dinner honoring past presidents at Bryant McClure Millhouse. From left to right are (first row) Mary Jo Gibson, Linda Wall, and Sarah Conley; (second row) Doris Rickman, Sue Moore, and Anne Murray; (third row) Linda Mason, Ann Messer, Marge Corte, Rachel Hill, Joyce Bryant, Anna Belle Jamison, and Ruth Carpenter.

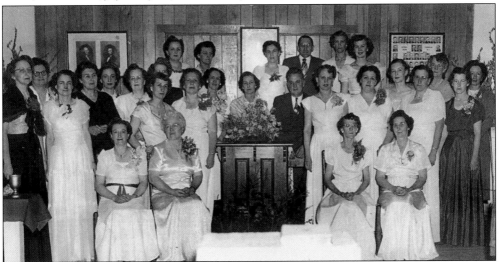

Eastern Star meets in 1953 for Molly Bolton's installation as worthy matron. From left to right are (first row, seated) Alice Ray, Blanche Parrish, Helen Snyder, and Nobia Murray; (second row) Hermie Bryant, Eula Carpenter, Juanita McKelry, Pearl Corbin, Dorothy Henry, Ida Grant, Margaret Tysinger, Katherine Crawford, Esther Cunningham, Molly Bolton, Edd Whitaker, Catherine Henry, Emma Jane Phillips, Mary Fisher, Lois Conley, Lassie Kelly, Frances Wilhide, and Margaret Bulgin; (third row) Ruth Whitaker, Ruby Bradley, Floss Allison, Jim Hauser, Lucille Phillips, and Evelyn West.

Dr. James Hillyer Fisher worked as a veterinarian in Macon County and Rabun County, Georgia, for 47 years. For much of that time, he was the only vet in the area. Dr. Fisher also served as the county coroner and as chairman of the Macon County Health Board. He assisted efforts to start a humane society at a time when strays were a serious problem. He was a true friend of all creatures large and small. The raccoon in this photograph appears to reciprocate the friendship. Dr. Fisher passed away in 2002.

Just hanging around, watching the world go by, and swapping stories with friends is a way of life that never grows old. This photograph was taken when the Clock Tower Square was a parking lot, and the local taxi provided a perfect gathering spot. Town was a busy place in those days, and there was always something to observe and comment on.

A produce seller has apples and fresh cider ready for fall festival visitors in 1991. The beauty and bounty of autumn has always given Franklin much to celebrate. Today's wildly popular Pumpkin Fest grew out of the earlier fall events. (Barbara McRae.)

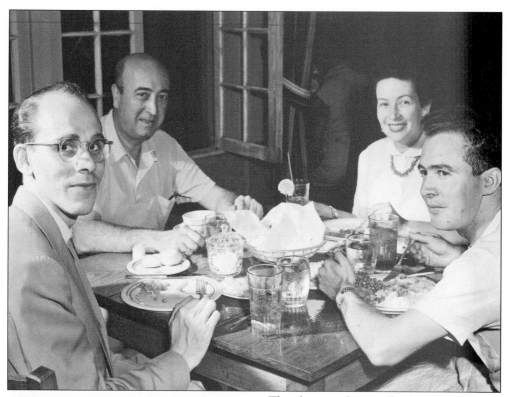

The photographer caught these diners at Kelly's Tea Room finishing their meal. From the empty plates, it must have been a good one. Sisters Elizabeth and Lassie Kelly opened Kelly's Inn and Tea Room in their Main Street home in April 1928. Lassie continued to operate the highly acclaimed restaurant for many years after her sister's death in 1933.

Viola Lenoir was widely considered the best cook in the county for more than a half-century. She learned under the tutelage of Elizabeth Kelly, who hired her at the age of 13 and bought her a cookbook. Kelly was a cook of some renown herself, and the tea room she operated with her sister was regionally famous. (Barbara McRae.)

Ann Hackett "Nan" Ray came to Franklin from Clayton, Georgia, to attend school. She met Matt Ray in Franklin; they married on May 30, 1879, and settled down to raise a large family. One of her grandchildren, Edward W. "Eddie" Ray, has had a fabled career in the recording industry. Nan Ray died in 1961 at the age of 101.

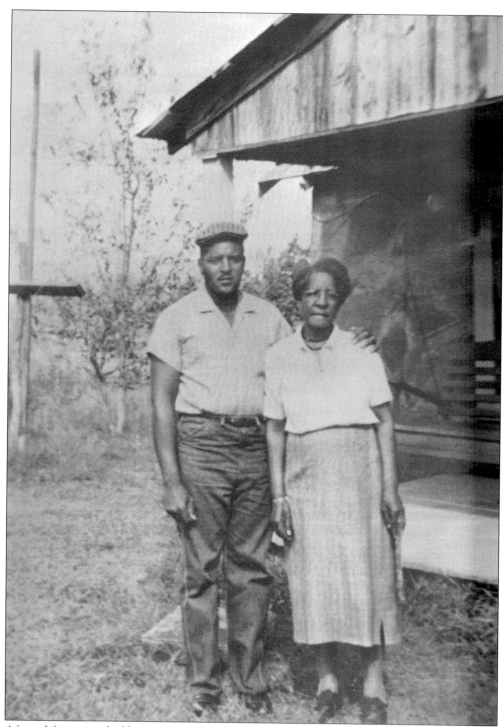

After a lifetime marked by service to the community, Jay Dee Shepherd, the grandson of slaves, was elected to the Macon County Board of Commissioners in 2002. He was the first African American to hold that position and the first to serve as vice chairman of the county board. He passed away in 2010. Jay Dee is shown here with his mother, Dicey.

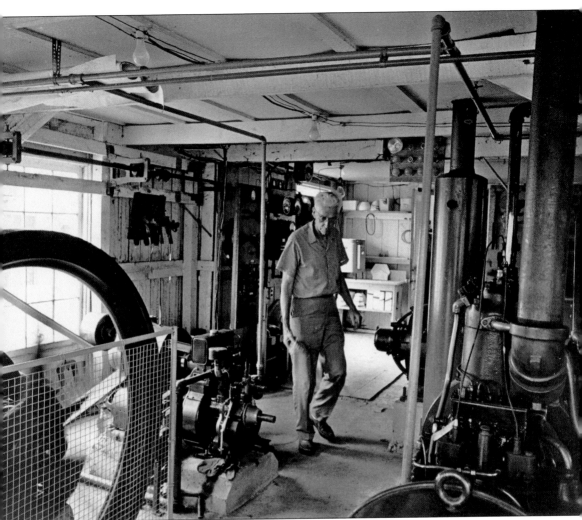

Edgar S. Purdom earned a reputation for design and craftsmanship during his years as a furniture maker in Franklin. He is shown in his shop in Wayah Valley, which specialized in custom-made furniture using walnut, cherry, maple, and hickory woods.

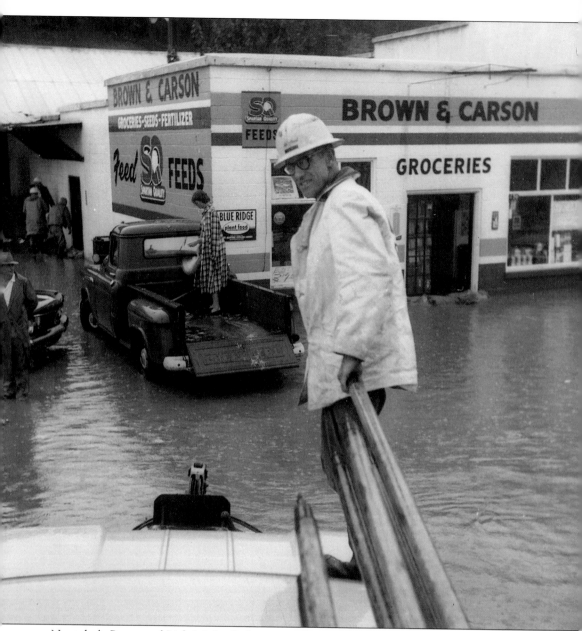

Nantahala Power and Light's John Bulgin uses a boat to determine damage from flooding from the remnants of Hurricane Hilda, October 4, 1964. Mayor W.C. Burrell estimated damage at more than $1.2 million; he and Rep. Roy Taylor asked President Johnson to declare Macon and Transylvania Counties as disaster areas. Damage to the Peak Line Furniture Company alone was put at $150,000. (Lisa Leatherman, Duke Energy.)

In the old Belk department store, Gerry Oliver and Ernest Kirkman work in the men's department. The store was the largest commercial business on Main Street and drew customers to town for many years. When it closed, Macon Furniture Mart occupied the building, next door to the new Franklin Town Hall.

Halloween is a magical holiday in Franklin, a time to clown around while enjoying fall colors and the joys of the harvest. In this 1991 photograph, a clown stands guard over a row of pumpkins during Pumpkin Fest in downtown Franklin. The event draws thousands of people every year, from near and far. (Barbara McRae.)

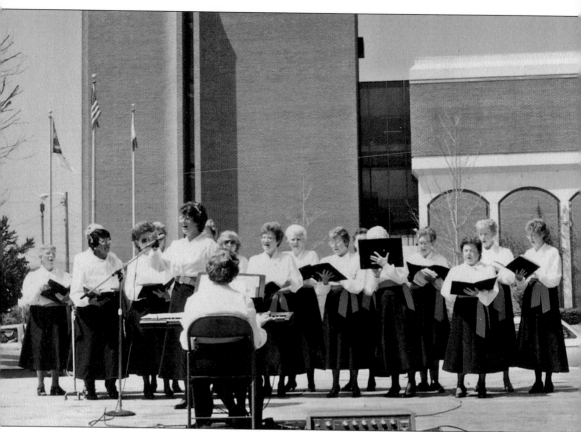

A popular choral group, the Carolines, performs on the square in 1991 during a street festival. The Macon County Courthouse rises behind them. The stage is made of temporary flooring over the basin of the old fountain. It would later become part of the gazebo, which would see many more performances and events through the years. (Barbara McRae.)

Volunteers reward themselves with a home-cooked meal following a hard day of work in the Big Sweep. The annual drive is part of a statewide effort to clear trash from public areas. People work under team leaders to clean specific sections. On this occasion, a cookout at Franklin Memorial Park and performances by local musicians made a happy ending to a long day. (Barbara McRae.)

A little girl has her face painted during a party for children at the Macon County Public Library. (Macon County Public Library.)

People stand in line to purchase books during a book fair sponsored by the Friends of the Library in 1982. The event drew huge crowds and was so successful that the organization decided to open a used bookstore that would provide a dependable source of income to benefit the Macon County Public Library. (Barbara McRae.)

Prelo Dryman (left) watches as fellow merchants Verlin Swafford (center) and W.C. Burrell (right) sweep the sidewalks of Main Street for a good cause: a broom sale for the Lions Club. The club, which was chartered in 1939, provides a host of services to the community. Eye care is a special focus of the group; it helps local people who have vision needs, as well as supports statewide programs.

Mayor Roy Cunningham sprinkles salt on the sidewalk in front of the Western Auto Store after a winter storm in the 1960s. Cunningham worked at the store for 25 years. He was a public-spirited man who served on the town board for 30 years, including several years as mayor. He was a Franklin Lion for 45 years.

Bill Norwood, also known as "Mr. Bill" of WLOS-TV's *Mr. Bill and Bozo* children's show, prepares to go up in the station's hot-air balloon during a promotion at Franklin Plaza about 1980. Winn-Dixie, the original anchor in the shopping center, is visible at right. The grocery closed in 2005. (Barbara McRae.)

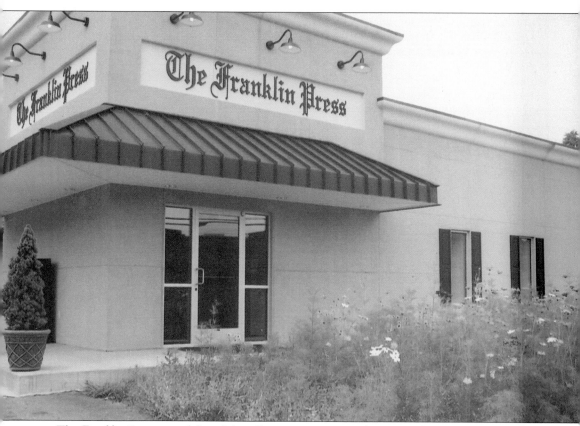

The *Franklin Press* moved from Main Street to its present home on the corner of Wayah and Depot Streets in the early 1970s, when Bob Sloan was editor. Sloan began his long association with the newspaper before World War II and wore many hats, including those of owner, publisher, and editor, into the 1980s. This image shows the building after its renovation and update in 2002. The present owner is Community Newspapers, Inc., of Athens, Georgia. (Barbara McRae.)

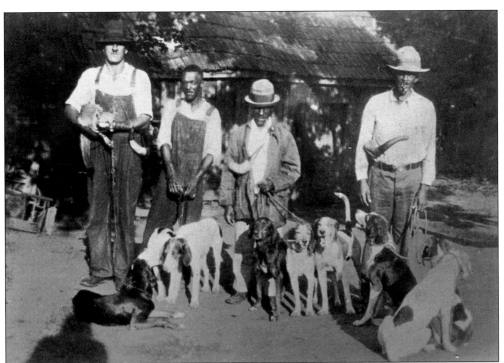

Hunting has long been a way of life for many in the mountains, enjoyed both for sport and for the food it puts on the table. These photographs show the pride sportsmen took in their hunting dogs and their skills. Above, the foxhunters back home from a day in the hills are, from left to right Ned Chavis, holding the fox they took; Canara Stewart; Weimar Wykle; and Eugene Thomas. The photographer's shadow is visible at lower left. The well-outfitted duo at right with the braces of birds are Jim Palmer (left) and Harley Mashburn (right). They brought their dogs with them to the photographer's studio to record their success.

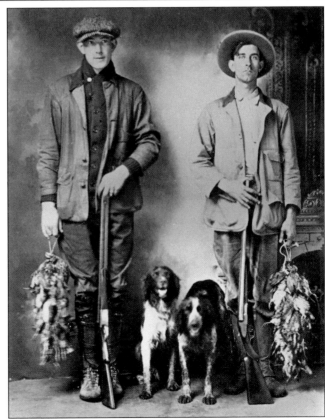

The Fourth of July parade was one of the biggest events of 1976, and everyone got into the act. Here, the Fontana Regional Bookmobile, decked in patriotic colors, travels proudly along the Main Street parade route during a Fourth of July parade. The bookmobile served rural library patrons in Jackson, Macon, and Swain Counties. (Macon County Public Library.)

Amour Cagle and his brother Gus had long careers in the restaurant business in Franklin, beginning in 1940. The brothers operated Cagles Café on Palmer Street together, but both also had restaurants of their own. Among others, Amour ran DeSoto Trail in the 1950s and Cagle's on US 441 South in the 1960s. Here, he is at work in one of his kitchens.

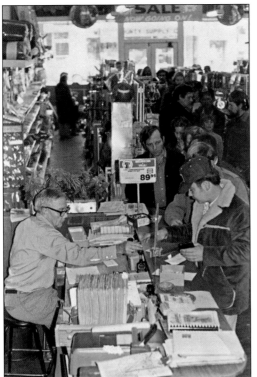

A long line forms as car owners wait to buy their tags at the Western Auto on Palmer Street. State law later changed the system to stagger sales through the year, but until 1981, all plates expired on December 31, leading to scenes like this one. Verlin Swafford and his staff at Western Auto handled local registrations and had their work cut out for them when the tags came due.

Carowinds' Yogi Bear visits with children at the Macon County Public Library on Porter Street in 1981. The library has long offered a great variety of programs to enthrall and educate children and make them readers for life; one reason is, perhaps, that the library continues to require ever more spacious quarters. (Macon County Public Library.)

Youngsters push apples toward the finish line with their noses in this heated competition, which took place in downtown Franklin in front of the old A&P. Franklin has a tradition of street celebrations and competitions going back to the earliest days. Today's events seem mild compared with the horse races and shooting matches favored by frontiersmen.

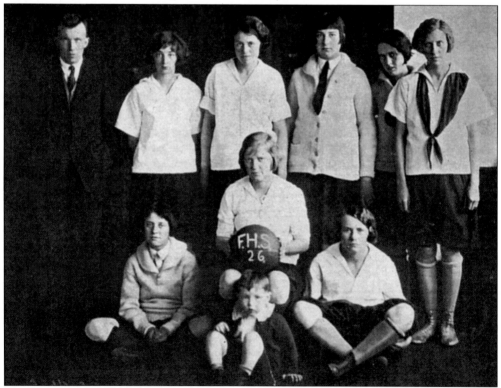

The Franklin High School girls' basketball team of 1926 posed with their little mascot, George Hunnicutt, for this group portrait. Members included Ina Henry, forward; Elizabeth Barnard, forward; Freda Siler (captain), guard; Glee Garner, guard; Hattie Lee Cabe, guard; Lovicia Justice, center forward; Helen Jones, substitute; and Ella Jones, substitute. The coach was Prof. S.L. Moss.

The boys' basketball team of 1926 included Phil McCollum, forward; Elmer Roten, forward; Willard Fox (captain), center; Don Henry (manager), guard; Jack Sherril, guard; Bill Higdon, substitute; Raleigh Shook, substitute; George Carpenter, substitute; and Ralph Womack; substitute. Professor Moss coached the Franklin High School team to a highly successful year.

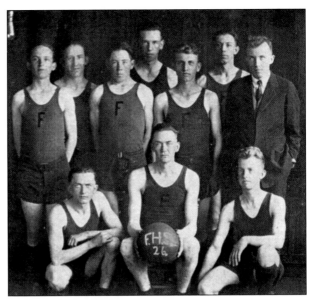

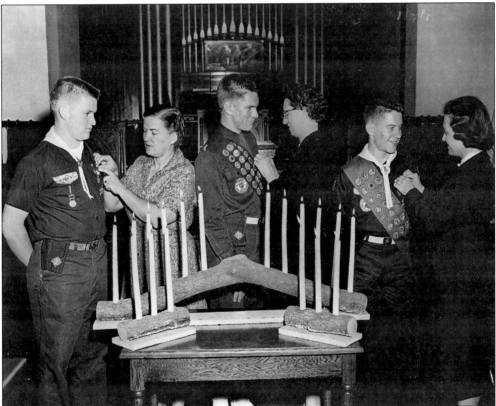

Franklin's strong scouting tradition is epitomized in this photograph of proud mothers pinning medals on their sons during a candlelit Boy Scout ceremony. Each of the two boys at the right wear sashes with 21 badges, which was the Eagle Scout requirement then. From left to right are Paul and Dorothy Cabe, E.G. Jr. and Marjorie Crawford, and John III and Dorothy Crawford. (Marjorie Crawford collection, Macon County Historical Museum.)

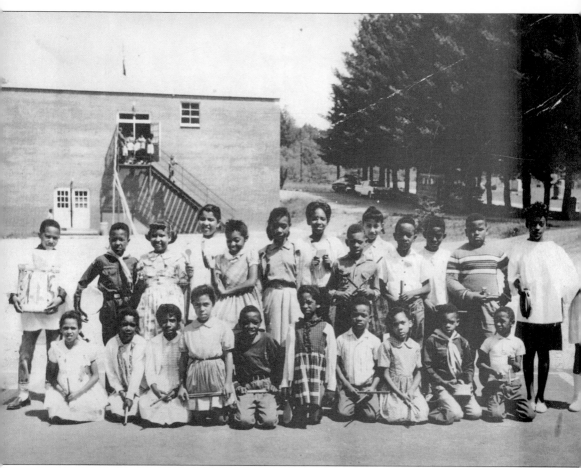

The Chapel School served Franklin's African American community before integration. This was one of the last classes at the elementary school. As the community was too small to have its own high school, the county provided a small stipend for students who wished to go out of town for further education. The building that housed Chapel School later became the school system's central office.

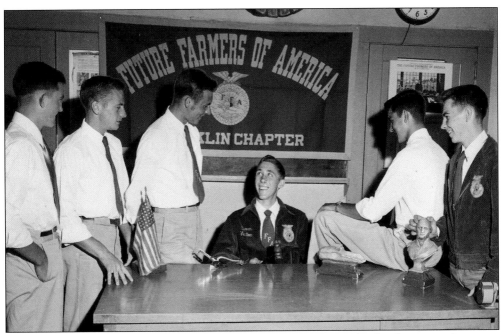

Agriculture was the mainstay of Macon County's economy for much of its history and remains important today. The Franklin Chapter of Future Farmers of America (FFA) has helped prepare young people for careers in farming and related fields. Here, from left to right, FFA members Sheffield, Mashburn, Barrett, Houston, Tippett, and Teague meet in a classroom of Franklin High School.

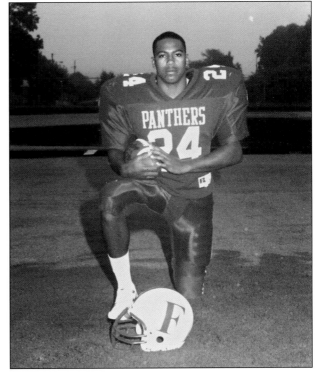

Shawn Bryson earned school records as a student-athlete at Franklin High School, including career kickoff returns for touchdowns in football and career triples and stolen bases in baseball. He played football at the University of Tennessee and was one of four captains for the 1998 National Championship Team. In 1999, Bryson was a third-round NFL draft pick for the Buffalo Bills and later played for the Detroit Lions. (Susie Bryson.)

Beth McIver leads the Lyndon B. Johnson Job Corps chorus in a number during a performance at the Macon County Public Library in 1978. The artist-in-residence program brought McIver and other gifted artists into the community. They shared their various disciplines with students and adult groups, while having the opportunity to grow professionally. (Macon County Public Library.)

Woodsy Owl is surrounded by young fans during this visit to Macon County Public Library in 1983. The US Forest Service icon brought the message, "Give a hoot—don't pollute!" to children in a whimsical fashion. The message resonates in Macon County, where US Forest Service lands make up about half of the total acreage. (Macon County Public Library.)

A team of young cloggers surrounds Rep. Lamar Gudger during his unsuccessful 1980 reelection campaign. Gudger represented North Carolina's 11th Congressional District from 1977 to 1981. He was in Franklin to speak at the Macon County Community Facilities Building, and the local dance team was there to perform at the event. (Barbara McRae.)

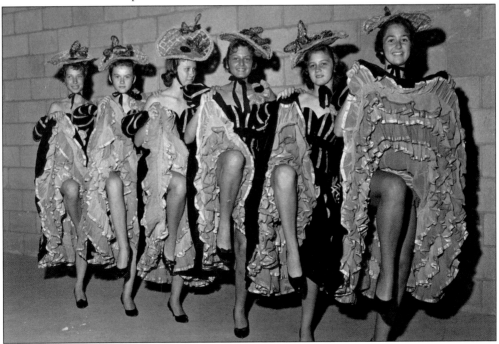

Can-can dancers in the *Red Stocking Revue* of 1960 (popularly called the "Follies") kick up their heels. The charity event was sponsored by the Franklin Junior Woman's Club to buy shoes for needy children. From left, the "Rockettes," as they called themselves, are Bobbie Medlin, Linda (Wallace) Armes, Suzanne (Cunningham) Williams, Tootsie Ledford, Jean (Dills) Swafford, and Frances Duncan. (Suzanne Williams.)

The Optimist Club's dunking booth was a popular feature of a street festival, the Franklin Games, in August 1991. Franklin MainStreet sponsored the games as part of its downtown revitalization program. The maples that provided shade in the public square died in a drought a few years later and were replaced. (Barbara McRae.)

The Franklin Garden Club's float draws admiring glances from bystanders as it passes Shorty's Grocery during the annual Christmas parade. The store, named for owner Clarence "Shorty" Mason, was a long-standing Franklin business. It was later situated on Palmer Street and was known as Mason's Food Palace, the last grocery in the downtown area.

Five

A PASSION FOR HERITAGE

After the US DeSoto Commission placed the route of the 1540 Spanish expedition through present Franklin, town leaders organized a 400th anniversary event. The June 1940 ceremony included a pageant, *Waters Flowing West*, directed by Edith Russell of Asheville. Along with professionals from Harrington-Russell Studios, the cast included several local residents playing Spanish ladies in waiting, Indian maidens, and Indian warriors.

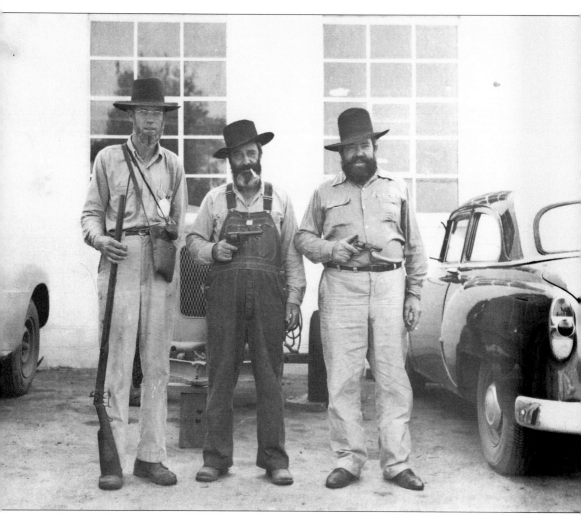

Local businesses entered wholeheartedly into centennial fever. These Nantahala Power and Light Company employees grew beards for the "Brothers of the Brush" competition. Here, they pose at the company shop in their guise as 1855 frontiersman. From left to right, they are John Bulgin (with a shot pouch, powder horn, and rifle), John McFalls, and Henry Wilkie, holding a Colt .32 revolver.

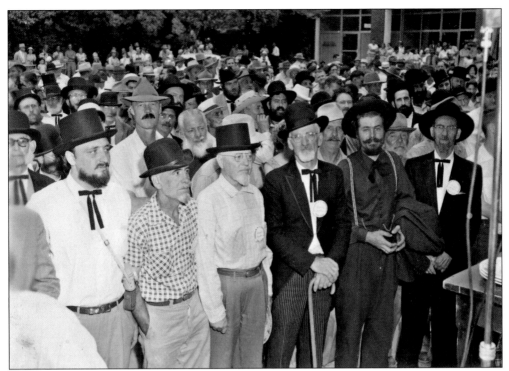

A crowd of bearded men faces the judges during the 1955 centennial. Those in front are competing for the best goatee. The number of contestants demonstrates how much enthusiasm the event generated. Alfred "Alf" Higdon, wearing the dark coat at center, was the winner. Higdon operated the Franklin Hardware Company from 1922 until his death in 1960.

Mayor W.C. Burrell (second from left) got into the spirit of things, growing an impressive set of whiskers for the centennial. He is joined in this photograph by other men with similar full beard, mustache, and side-whiskers. From left to right are Samuel Higdon, Mayor Burrell, William "Will" Teem, unidentified, and William "Billy" Higdon.

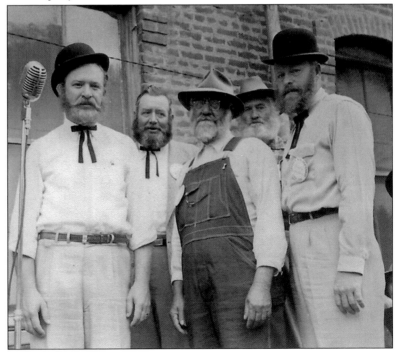

Alfred Teem and Pauline Thompson were among the centennial participants who took advantage of the opportunity to have their portraits made in costume. The event was probably the most photographed in Franklin's history to that point. The portraits, the costumes themselves, other mementos, and stories of the unforgettable party have since become treasured hand-me-downs for many local families.

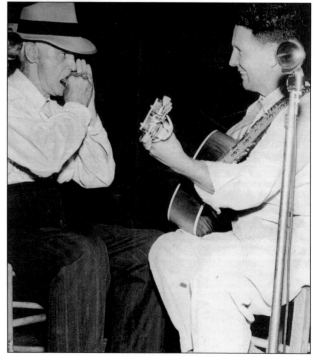

The 1955 Franklin centennial created a surge of interest in local heritage and history. Lessons learned during the anniversary party proved helpful in organizing the many events that followed. Here, Hunter Young (guitar) and Frank Cunningham (harmonica) perform during the 1956 Franklin Fall Festival. (June Ferguson Hawkins collection, Macon County Historical Museum.)

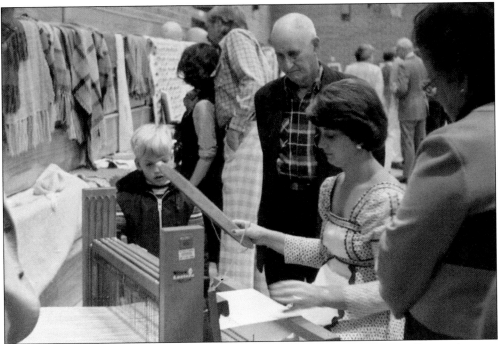

In 1818, settlers began arriving in the territory that would become Macon County but was then part of Haywood. The population grew large enough by 1828 to warrant creation of a new county. One hundred and fifty years later, the Macon County government hosted a day of events to celebrate the sesquicentennial. A reception, formal program, exhibitions, and heritage demonstrations took place in the new community building. Like the 1955 town centennial, the event generated a swell of interest in local history and tradition. The fiber arts in particular drew attention. Above, a weaver demonstrates her craft to visitors, and below, a quilter shows how to stitch a coverlet using a large embroidery hoop. (Both, Barbara McRae.)

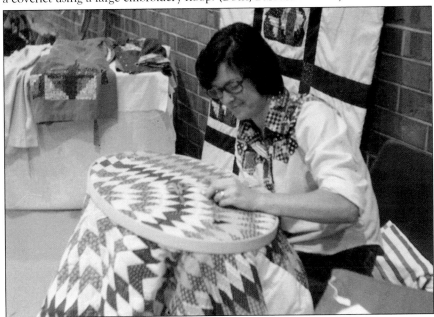

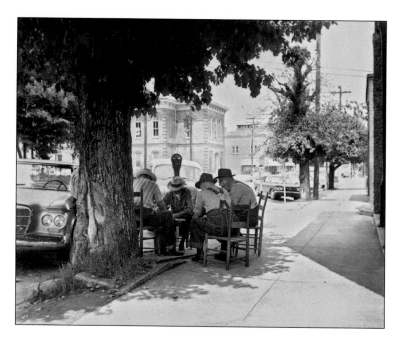

The game of checkers is one old tradition that long endured in Franklin. On a fine day, checkers players inevitably gathered in front of the Pendergrass Store, which is now the Macon County Historical Museum. Museum staffers still put a checkerboard and chairs on the sidewalk as an invitation to bystanders to sit down and play.

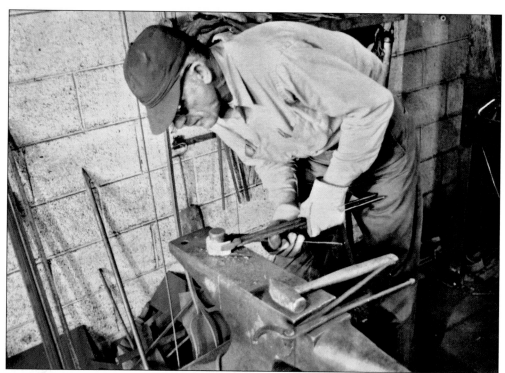

Among Franklin residents who preserved the old crafts was John Bulgin, seen here in his blacksmith shop. He learned his skills from his father and passed them along to a third generation. John belonged to the Southern Highland Craft Guild, a prestigious craft organization with a juried membership. He shared his craft with others through demonstrations at regional shows and festivals. (Randolph Bulgin.)

Maco Crafts grew out of Macon Program for Progress, the local Community Action Agency, in the early 1970s. The crafts cooperative eventually included more than 200 members. A training program helped crafters develop their skills and artistic ability, and Maco became noted for the high quality of its products, particularly its quilts. Nellie Clouse was one of the most highly regarded of the quilters.

There were some glorious moments for Maco Crafts along the way. Quilters created the "World's Largest Quilt" for exhibition at the 1982 World's Fair in Knoxville, Tennessee, and obtained some major design contracts for other large pieces. Here, quilters pose on the "World's Largest Bed," created by Maco's woodworkers to display the quilting masterpiece. (Margaret Ramsey.)

One of the demonstrators Maco Crafts brought in for its on-site shows was noted folk artist Harold Garrison of Weaverville, North Carolina, who made wooden flowers by shaving sticks. A bouquet of the flowers is visible at left. Examples of Garrison's more complex work are in the Smithsonian's folk art collection. (Barbara McRae.)

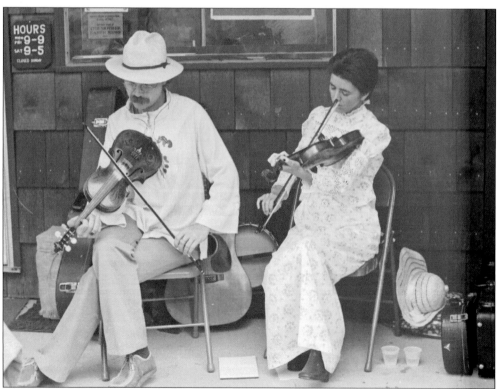

Musicians perform during one of the special events Maco Crafts hosted at its store on the Georgia Road. Traditional mountain music was right at home among the heritage arts being demonstrated at these events, the Spring and Fall Flings. Eventually, the older crafters passed on, and younger members found other employment. The co-op closed after more than 25 years of preserving the old ways and improving crafters' lives. (Barbara McRae.)

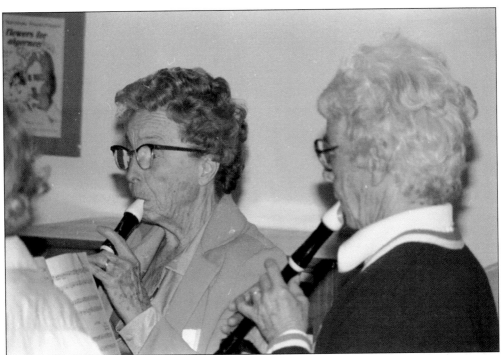

Music of all kinds is much loved in Macon County, especially the traditional mountain forms. Saturday nights in the summer are reserved for Pickin' on the Square, free outdoor programs that are sponsored by the town. Other performances, from classical concerts to 1950s revivals to front-porch bluegrass, take place regularly, and the county has produced a number of notable country gospel groups. In these photographs, women present a program of recorder music at an Extension Homemakers' luncheon and fiddler Ted Cook (standing) plays in a pick-up session with a friend. (Above, Barbara McRae; right, Bob Scott collection, Macon County Historical Museum.)

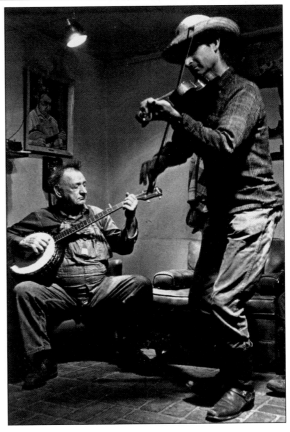

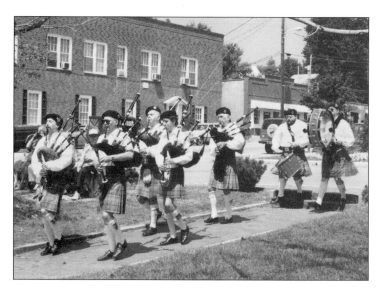

The Highlands Pipe Band performs on the town square in 1991. Interest in all things Scottish burgeoned in Macon County after the Scottish Tartans Society established a museum in Highlands in 1988. The museum, which moved to Franklin in 1994, serves as a center for Scottish heritage in the region. Bagpipes are now as much at home in the town as fiddles. (Barbara McRae.)

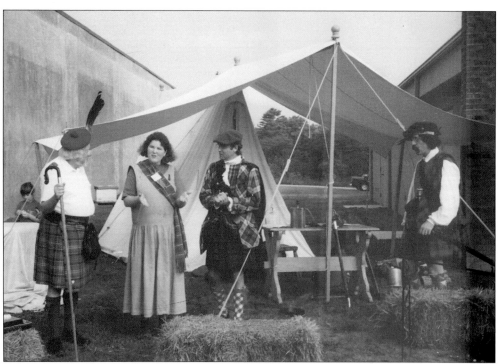

Dr. Gordon Teall of Teallach (left), president of the Scottish Tartans Society, confers with volunteer Claire Suminsky about an exhibit as they prepare for a Franklin Town Fest. Teall was instrumental in creating the Scottish Tartans Museum, which opened in Franklin in 1994. The Taste of Scotland street festival later became an annual Franklin event. (Barbara McRae.)

Reenactors chat with a visitor to the Little Tennessee River Greenway in Franklin about 2001. Building the trail was a cooperative effort between the county and Duke Energy. The greenway follows the river and Cartoogechaye Creek, a major tributary, for four miles. It also features playgrounds, large shelters for group gatherings, benches, canoe put-ins, and plenty of wildlife and natural areas for contemplation. (Barbara McRae.)

North Carolina representative Roger West (left) and North Carolina senator Robert "Bob" Carpenter talk with Barbara White, director of the Macon County Historical Museum. The interior of the museum, which is located in the old Pendergrass Store, has significant architectural details, such as the built-in counter and supporting pillars of yellow pine that are visible in this photograph. The displays offer fascinating glimpses into the history of Franklin and Macon County. (Barbara McRae.)

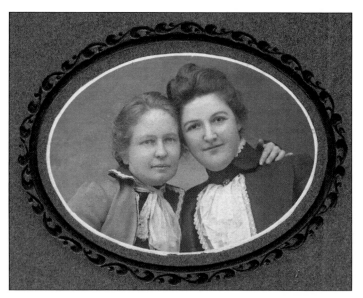

Margaret Redding Siler (left), shown here with her friend and cousin by marriage Elizabeth Kelly (right), was a native of Macon, Georgia, who married Frederick L. Siler, a Franklin doctor, in 1900. She became a vocal supporter of the mountain people and preserved much of their history and folklore through her writings and radio program. Her collected pieces were published in *Cherokee Indian Lore and Smoky Mountain Stories.*